Capture the Light

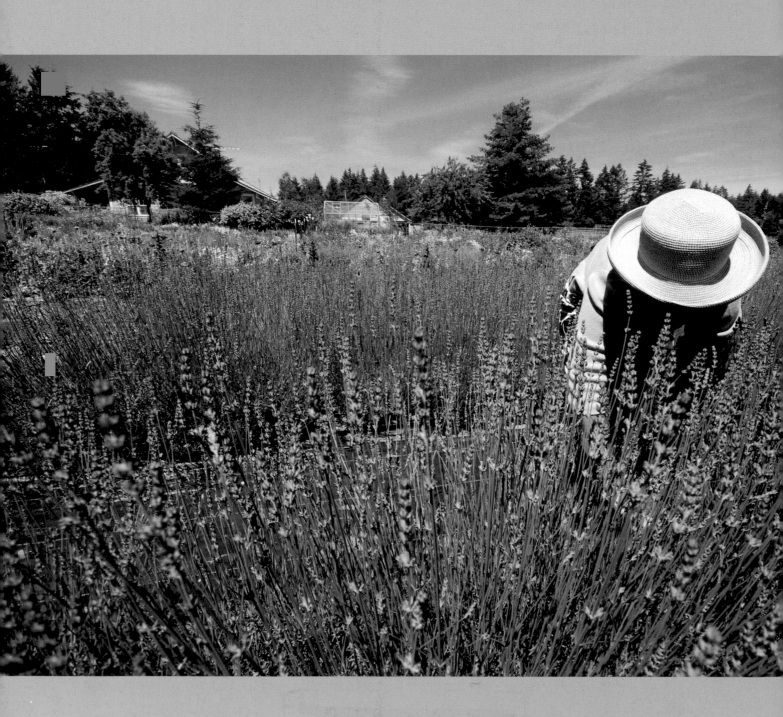

Capture the Light
A Guide for Beginning Digital Photographers

Steve Meltzer

LARK BOOKS

A Division of Sterling Publishing Co., Inc.
New York / London

Book Design and Layout: Tom Metcalf – tommetcalfdesign
Cover Design: Thom Gaines – Electron Graphics

Library of Congress Cataloging-in-Publication Data

Meltzer, Steve.
 Capture the light : a guide for beginning digital photographers / Steve
Meltzer.
 p. cm.
 ISBN-13: 978-1-60059-259-1 (pb-trade pbk. : alk. paper)
 ISBN-10: 1-60059-259-7 (pb-trade pbk. : alk. paper)
 1. Photography–Lighting. 2. Photography–Digital techniques. I. Title.
 TR590.M45 2008
 778.7'2–dc22

 2007033240

10 9 8 7 6 5 4 3 2 1

First Edition

Published by Lark Books, A Division of
Sterling Publishing Co., Inc.
387 Park Avenue South, New York, N.Y. 10016

© 2008, Steve Meltzer
Photography © 2008, Steve Meltzer unless otherwise specified
Cover Photos:
© Jeff Wignall: boat on a river; two young women; fishing at sunset
© Steve Meltzer: all other photos
Illustrations © 2008, Lark Books unless otherwise specified

Distributed in Canada by Sterling Publishing,
c/o Canadian Manda Group, 165 Dufferin Street
Toronto, Ontario, Canada M6K 3H6

Distributed in the United Kingdom by GMC Distribution Services,
Castle Place, 166 High Street, Lewes, East Sussex, England BN7 1XU

Distributed in Australia by Capricorn Link (Australia) Pty Ltd.,
P.O. Box 704, Windsor, NSW 2756 Australia

If you have questions or comments about this book, please contact:
Lark Books
67 Broadway
Asheville, NC 28801
(828) 253-0467

Manufactured in China

ISBN 13: 978-1-60059-259-1

For information about custom editions, special sales, premium and corporate purchases, please contact Sterling Special Sales Department at 800-805-5489 or specialsales@sterlingpub.com.

Dedication

For HCB and DRD

Contents

Introduction

We live in a light-filled world that we mostly take for granted. All too easily we become inured to our surroundings, hurrying everywhere and hardly noticing the various and beautiful ways that light illuminates our daily life. Yet every once in a while we come face to face with something like a huge tropical sun sitting over the ocean, or a mist-filled morning sunrise, perhaps even light streaming through a window, and for a moment it reawakens our appreciation of light.

What I hope to do with this book is encourage you to appreciate light all the time, and to learn to use it to take great pictures. It is essential to be aware of light so that we can create the best possible photos.

Light has always fascinated photographers and other artists. It changes constantly with the time of day, the season of the year, the weather, and even with location. Its variety is infinite, wondrous, and always surprising.

As you pay more attention to light and lighting, your control of pictures will increase. Observing light and being aware of how a particular light affects a photos is the key. Knowing how to effectively use light will improve your photography. While light might appear to be a complicated subject, you needn't get bogged down in all the technical details. Each section of this book is loaded with easy-to-grasp tips and techniques that will improve your pictures. Pretty soon you'll intuitively make the connection between the lighting and the appearance of the picture.

So that's the plan. In this book you'll learn how light can add impact and color to your photographs. I want to show you how to capture light so your photos become more than ordinary snapshots. I want you to make pictures that you'll love to show friends, send to relatives, and be proud to display in your home.

Have fun!

Steve Meltzer

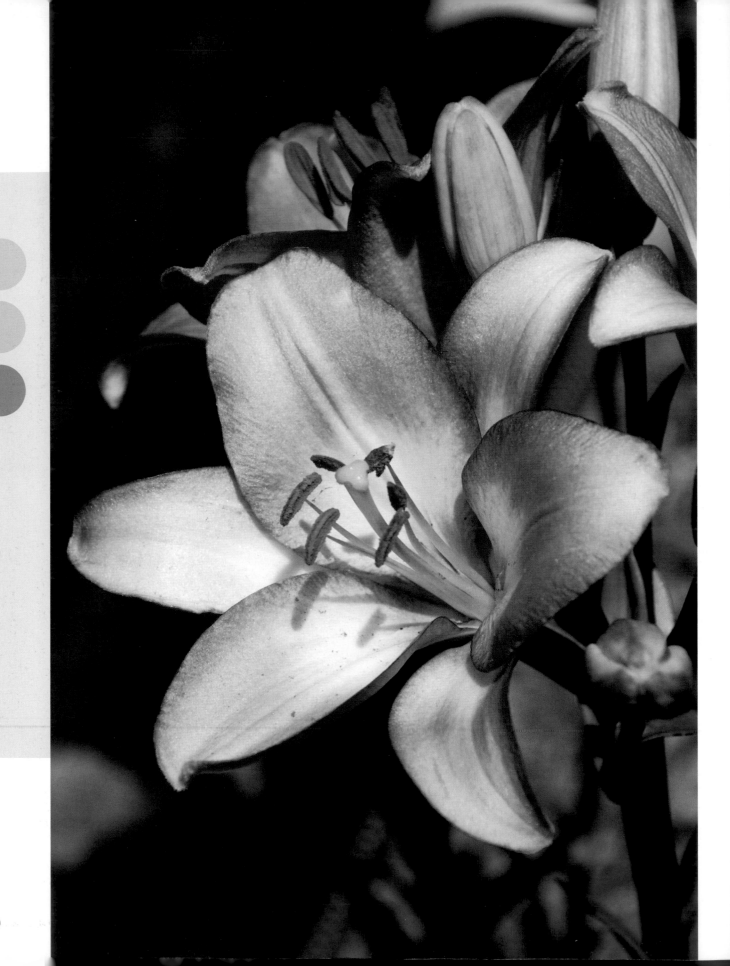

The Digital Camera

The very word photography means "writing with light," so light is at the very essence of photography. What is interesting is that light is different under so many various circumstances. Natural outdoor light ranges from the soft pastel pinks of a sunrise to the fiery reds of a sunset to the intense blue sky of a sunny day. Indoors, the light varies as well, from greenish fluorescent to warm, yellow-orange incandescent. Let's take a quick look at our writing instrument, the digital camera. No matter which of the several different types of digital cameras you use, the first step to improving your photography is to understand the camera so that you an best capture the light.

Types of Digital Cameras

You will find three primary types of digital cameras. The most basic is the point and shoot (P&S), which is typically small with a permanently attached lens and usually a built-in flash. Most often you compose the picture using an LCD monitor on the back of the camera, though some larger models also have an optical viewfinder. These are the least costly and easiest to use. Since many of the functions and settings are automated, you literally point the lens at your subject and press the shutter release to shoot the picture.

Note: While cell phone cameras are fun and convenient, they are quite limited, lacking controls that allow you to take advantage of difficult lighting conditions.

A point and shoot camera usually offers less control to the photographer than EVF and D-SLR cameras.

You can make high-quality photos with EVF cameras, many of which offer a large zoom range.

D-SLR cameras are increasing in popularity, providing sophisticated features, including interchangeable lens systems.

A more advanced type of digital camera uses an electronic viewfinder (EVF—a small TV screen) and offers more control over its functions. Known by various names (advanced compact, bridge camera, etc.), this type falls between the point and shoot and the digital single lens reflex (D-SLR) in its size, weight, range of features, and lens performance.

The D-SLR is the camera of choice for advanced amateur and professional photographers. It is the most versatile, allowing you to take complete control of functions and settings, as well as permitting a wide selection of interchangeable lenses and additional accessories. Using a mirror and pentaprism system, the D-SLR viewfinder lets you see exactly what the lens sees, making framing precise and simple. D-SLRs focus more quickly in low light and have little or no shutter lag, along with more advanced image processors.

One great feature of all digital cameras is the ability to display an image on the LCD monitor immediately after shooting. This allows you to review the photo and determine its quality on the spot. You can reshoot the picture if you are dissatisfied with the results—no waiting for the film to come back from the photofinisher.

No matter which type of camera you use, don't be afraid to explore. You won't ruin your camera by experimenting with its menus and controls. Understanding your camera's features and functions will complement your understanding of light and enable you to improve your ability to shoot great pictures.

Resolution

Resolution refers to the quantity of pixels in an image. This can usually be adjusted by your camera's recording choices or in the computer using imaging software. The maximum resolution of your camera is the number of pixels on its sensor. An 8-megapixel (MP) sensor has a resolution of 8 million pixels, but digital cameras often provide the choice of several resolutions (image sizes) when shooting JPEGs. This means you are able to create smaller image files that occupy less space on a memory card or in your computer's hard drive. I suggest selecting the highest recording resolution possible if you plan to print your photos, and smaller sizes if your only goal is to email your photos or upload them to the Internet.

The LCD monitor allows you to review your pictures on the spot, and can give you a great deal of information about the photo you have just recorded.

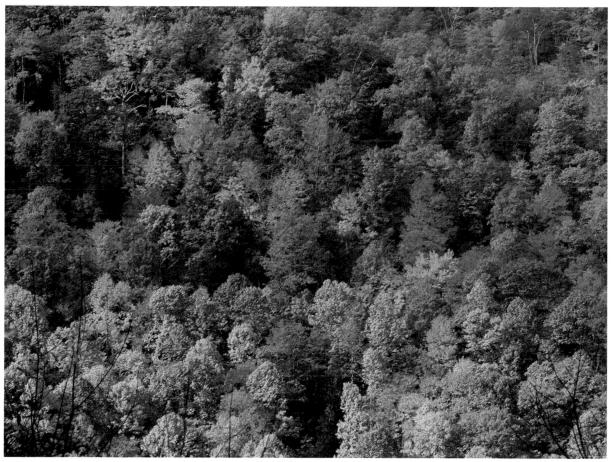

This picture is actually a small portion of a larger photo. High pixel resolution gives you greater latitude for cropping and also allows you to make bigger prints. © Kevin Kopp

File Types & Image Quality

Many digital cameras allow a choice of file formats. Most common are RAW and JPEG. RAW files have little or no processing applied after they are recorded by the sensor. JPEG is a compression standard that is used universally for digital photography. These files are processed internally by the camera. They can also be saved at various degrees of data compaction: for instance low, medium, or high. So, for example, you can choose to record a high resolution (large size), low compression (high quality) JPEG; or perhaps a low resolution (small size), high compression (lower quality) JPEG.

The RAW format gives you more ability during computer processing to make changes to the digital file without degrading it, but RAW files require special image-processing software. JPEGs, on the other hand, are universally supported and are more than sufficient for most uses. If you don't want to spend the computer time adjusting your RAW files, I suggest setting your camera for high-resolution, low-compression JPEGs.

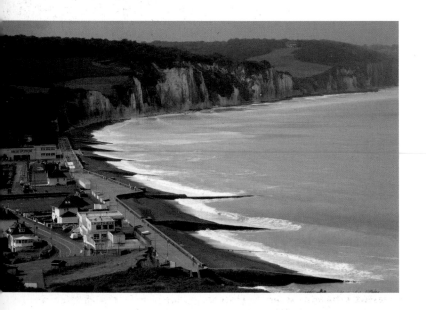

Exposure

Exposure is fundamental because it's the bridge that connects light to your camera. Correct exposure occurs when light reaches the sensor and produces a richly toned and accurately colored picture, or the creative effect you envision. The camera's metering system adjusts the aperture and shutter, which, along with ISO, makes sure that the correct amount of light is used.

The camera's aperture, or f/stop, is an adjustable opening that controls the amount of light entering through the lens to strike the sensor. The smaller the opening, the larger the f/number. Consequently, f/16 allows less light than f/4.

The shutter controls how long the light strikes the sensor. A digital camera is pre-programmed with dozens of combinations of aperture and shutter settings that will yield the correct exposure for any amount of light according to the camera's built-in metering system.

It is a neat thing to note that the aperture and shutter speed settings work in equal steps, so that different combinations produce equivalent exposures. Each change of one stop in either aperture or shutter speed will double or halve the light. This means that you get the same exposure if you increase one setting and decrease the other in equal steps. For example, using f/5.6 at 1/250 second will produce the same exposure as f/4 at 1/500 second and f/8 at 1/125 second.

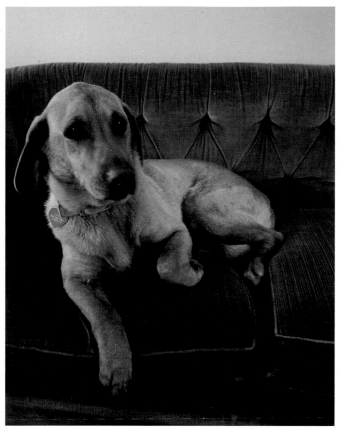

Low light can create a number of photographic challenges. Here without flash, even by raising the ISO setting to 800 and selecting a shutter speed of 1/20 second, the aperture was wide open, leading to a shallow depth of field. Notice that the dog's nose is not as sharp as its collar. © Kevin Kopp

The ISO setting alters your digital camera's sensitivity to light by adjusting electronic data from the sensor to values that are comparable to film ISO speeds. At high ISO settings, you need less light to record a picture. For most photography, ISO settings at 200 or lower will give the best results. Image quality suffers at higher settings (ISO 800 or 1600 for example) as digital noise correspondingly increases. However, in low light, for example when the weather is overcast or you are shooting indoors without flash, you may need to increase ISO.

Exposure Modes

Digital cameras have built-in exposure meters that measure the light and set the camera's aperture and/or shutter speed. You can generally select from several different exposure modes that tell the camera how to operate in order to determine correct exposure. Often you select these exposures from a mode dial on top of the camera that uses icons to depict the different choices. Here's a rundown of common exposure modes and what they do.

AUTO Exposure Mode: This is a fully automatic (Green) mode in which the camera sets both the aperture and shutter speed based on its metering. It's designed for general photography and works well in most situations. It also automatically applies additional settings, depending on the camera in use, such as white balance, focus mode, and ISO. (We'll learn more about white balance and its importance in the next chapter.) The icon for this mode is usually an A in a camera outline or the word "AUTO".

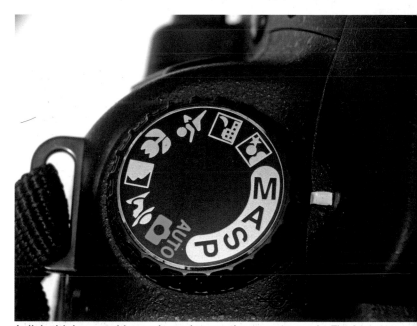

A dial with icons and letters is used to set the exposure mode. The icons represent automated settings for scene-specific situations, such as sports (runner), landscape (mountains), and close-up (flower).

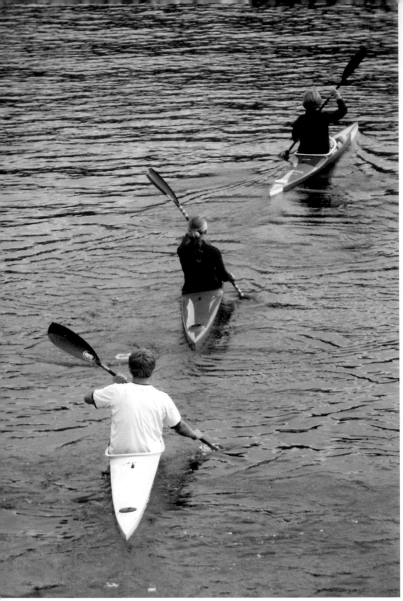

Use Shutter Priority mode when trying to control action. At 1/400 second, the shutter was fast enough to freeze the motion of the paddles in mid air.

Program Mode (P): Like AUTO, this mode also sets the aperture and shutter speed automatically, but most P modes allow the photographer to shift the shutter speed and apertures while retaining the correct exposure. In more advanced cameras, this mode also lets the photographer select the white balance, focus mode, ISO, etc. It's good for general photography when you want more control than AUTO.

Aperture Priority Mode (A, or sometimes Av): The photographer selects the lens aperture, and the metering system sets the shutter speed for correct exposure. Setting the aperture allows the photographer to control the depth of field, which is the area of the picture that is in acceptably sharp focus from front to back. A small aperture expands depth of field (good for landscape photography, for example), while a large aperture limits depth of field so that the subject pops in front of a blurred background (good for portrait or wildlife photography).

Shutter Priority Mode (S, or sometimes Tv): Shutter Priority means the photographer selects the shutter speed (how long the shutter is open) and the camera sets the aperture for correct exposure. Use of this setting is connected to motion. Short exposures (times of 1/250 or less) are used to freeze action, while relatively long exposure times (longer than 1/15 second) are used to create blur.

Manual Exposure Mode (M): In the M Exposure mode, the photographer selects both the aperture and shutter speed. This is particularly useful when you need total exposure control for creative effects.

Scene-Specific or Subject Modes: Many cameras come with exposure modes for specific subjects or situations. These can be for portraits or landscapes, or for specialized situations like fireworks or starry nights. It is a good idea to experiment with these modes to see if they work as advertised. While they can be helpful in some situations, their fixed settings take control away from you as the photographer.

Exposure Compensation (+/-)

You will usually find a button on the body of your digital camera (separate from the Exposure Mode dial) marked with a plus and minus sign. This is the exposure compensation control that lets you override the exposure choice made by your camera. Well, you may wonder, with all the technology built into your camera, why would you need to override its choices. The answer is simple.

A camera has no awareness. Its meter assumes a scene is middle gray. It doesn't know if it is pointed at a white cat on a snowy field or a black cat in a coal bin. Cameras merely measure the light that reaches the sensor, albeit in sophisticated ways, and adding up all the measurements, set the aperture and shutter to produce a medium gray (known in the photographic world as 18% gray). So it is possible for a scene to "fool" the camera's metering system into over or under exposing.

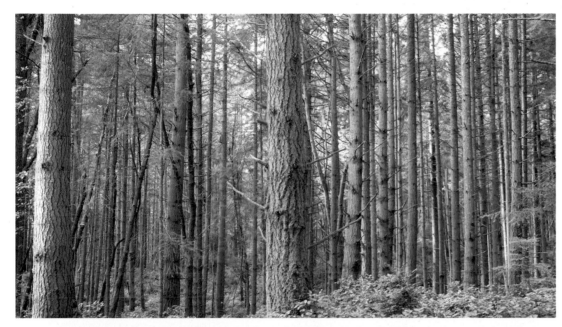

The camera's metering system adjusted for all the dark tones in the woods by recording a picture that was a bit too bright (top). Setting the exposure compensation to -1 helped return the forest to the way it really looked (bottom).

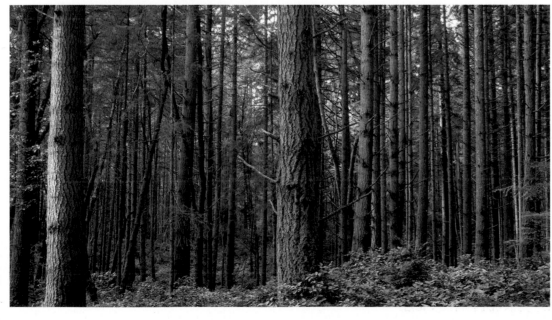

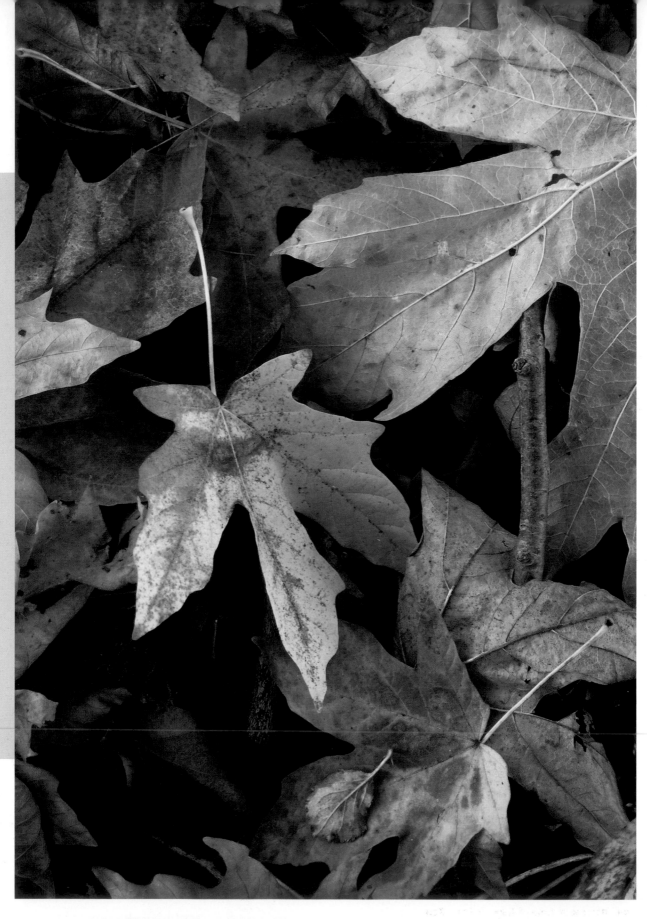

Light and Color

2

The sun is the source of natural light, pouring tons of energy into space every second. Visible light is a very thin slice of this broad range of energy that is known as the electromagnetic spectrum. This visible band of solar energy, with wavelengths between approximately 400 (violet) and 700 (red) nanometers (one billionth of a meter), is sandwiched in the spectrum between invisible ultraviolet and infrared radiations. These in turn are surrounded by gamma rays and x-rays with shorter wavelengths, and microwaves and radio waves with increasingly longer wavelengths.

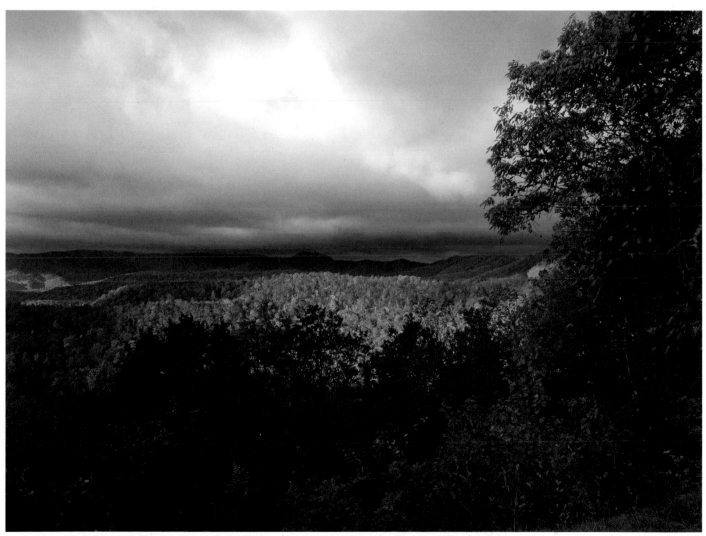

Sometimes the light itself is the subject of the photograph. In this landscape, the play between light and shadow illuminates the autumn foliage. © Kevin Kopp

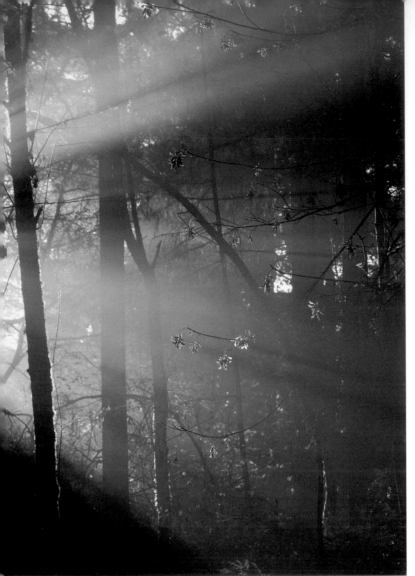

The direction of light changes with the seasons and with the time of day. This photo, taken close to noon in late autumn, illustrates how low in the sky the sun is. Moisture in the air is responsible for the rays of light coming through the trees.

As you read about visible light, you'll soon realize that you already know quite a bit about it; you just haven't had the official names for these things before. Let's look at the qualities of light, found in both natural and artificial sources, with our own experience in mind.

Direction

The direction of light has a big impact on the way a photo will look, affecting texture and shape of subjects. Our language is full of directional descriptions for light. We say the sun is up in the sky, or there is an overhead light in the living room. In fact, we regulary identify light by its direction. Light from a source in front of the subject is called front light. Light coming from either side is known as side light. And light from behind the subject is back light. Pretty straightforward.

Notice there are two planes of light: The vertical and horizontal. The vertical plane would have light coming from above or below the subject at any number of different angles. For example, the sun travels in an arc above us, going from very low on the horizon to directly overhead at noon. Similarly, the sun, or any light for that matter, can have a horizontal position in relation to the things you are photographing, coming from behind you to shine at your subjects, or from behind your subject to shine toward your camera.

In terms of vertical light, the more directly overhead your source, the flatter the light, producing fewer shadows. Light coming from below a subject, known as under lighting, is a well-known technique in horror films. Most of us first experienced under lighting sitting around a campfire when someone jumped out of the dark with a flashlight under their chin. However, there are a few other situations in which under lighting is advantageous, such as photographing glassware.

Front light casts shadows away from the camera so that we don't readily see them. Shadows can be important because they are the visual clues in a two-dimensional picture that tell the viewer about the shape and texture of the three-dimensional subject. So front light reduces or actually eliminates the clues that tell us about shape and texture.

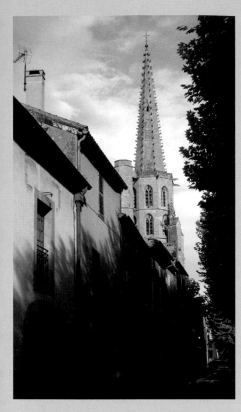

Strong side light helps bring out all the surface texture of this French church. Notice how the strong shadows of the trees are used to help frame the steeple.

The trick for getting good backlit images is to avoid, at least as much as possible, including the light source in the picture. When outdoors, either frame the composition to keep the sun out of the photo, or position yourself so that the sun is far to the side of the frame or is blocked behind your subject.

Scenes with back lighting can fool your camera's meter. It will usually read the bright light in the background and consequently underexpose the subject. In this case, you can use the built-in flash to light your subjects face.

If you choose not to use flash, you can set the exposure compensation control to in this situation. The typical compensation setting for back lighting is +1.5 stops, though you should review the image in your camera's LCD and make adjustments as necessary. However, be careful. Allowing more light to reach the sensor will help the subject look right, but it may end up overexposing the background.

Side light strikes the subject at an angle that accentuates shadows, so the effects of side lighting are usually more interesting than the flatness of overhead or direct front lighting. Side lighting produces more information about contour and texture. If you are photographing the Grand Canyon or a skyscraper, angular side light will give their shapes definition. That's why the hours between 10 A.M. and 3 P.M., while the sun is more overhead and less at an angle, are for siesta and lunch when I'm traveling and sightseeing.

Back Lighting

I like shooting against the light, a technique with the fancy name of "contre jour" photography, which simply means that your subject is lit from behind (that is, the subject is between you and the light source). This includes scenes where there are very light or white areas behind the subject. I like to use back lighting because it creates striking images of ordinary objects, and I love the way the light outlines the subjects.

© Robert Ganz

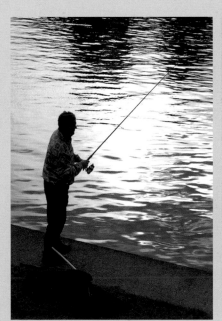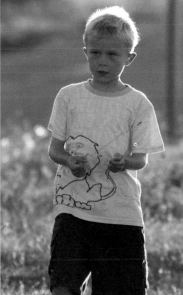

"Contre Jour" is the fancy name for shooting against the light. Subjects will become silhouettes when they are lit from behind by bright backgrounds. Or, fill the front of the subject with light to see detail and create a rim effect, as shown in the outline of the boy.

After a rain is the time to chase rainbows with your camera. I prefer to set the white balance to Daylight because other settings will shift the camera's response to color and some of the rainbow's hues may be lost.

The incandescent lighting inside gives an orange color cast to this interior, while the cooler light outside has a blue cast.

Color Temperature

All sources of light have a certain hue, or color temperature (measured as degrees on the Kelvin scale). This temperature (not a thermal measurement) corresponds to different color casts: bluish in forest shade (approximately 7500K), redder under incandescent lighting (approximately 2700K). Light, and its temperature, also changes throughout the day and with different types of weather. There's the lovely pink of a summer morning, the flat white light of an overcast day, and the brilliant reds of a winter sunset.

We've all seen a rainbow and its colors: red, orange, yellow, green, blue, indigo and violet. White light is a mixture of all of these colors. Daylight (approximately 5500K) consists of the light from the sun plus the light bounced off the sky. In the shade of a tree, the light is bluer because direct sunlight doesn't reach below the tree, only the light bounced from the blue sky does.

Our brains, through our eyes, interpret what we see and adjust for these variations in color temperature, so that we hardly notice the warmth of incandescent house lights or the greenish cast of fluorescents. In fact, we make adjustments for a number of different colored light sources within a single scene. But cameras, objective recorders that they are, don't discriminate. So they must be adjusted for different color temperatures. That's the function of the white balance (WB) control, which allows the camera to make processing adjustments to record true whites and accurate colors in a picture.

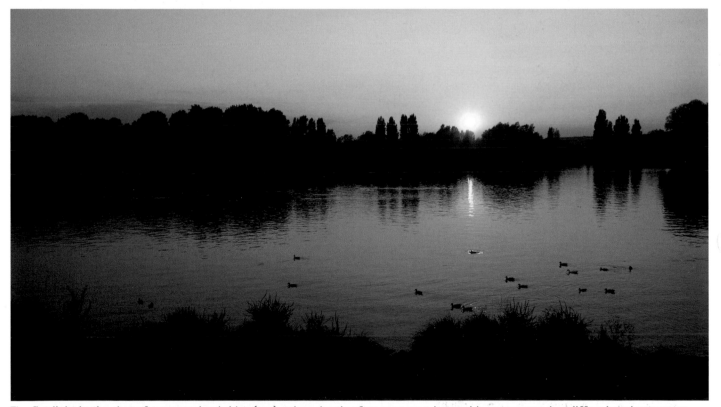

The flat light in the shot of a suspension bridge (top), taken shortly after noon on a hot and hazy summer day, differs in color temperature from the subtle reddish orange of the sunset over the river Seine.

White Balance

The camera's white balance system adjusts your camera for the color of the light source so that whites will be rendered neutrally and colors will be rendered accurately. White balance makes a white surface white in the picture, eliminating color cast. If the white is white, all other colors will be accurate too.

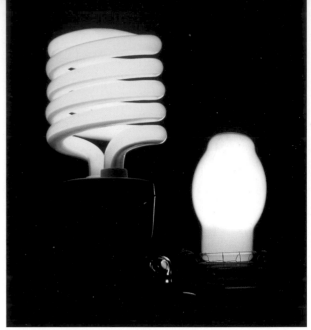

When the camera's white balance is switched to Tungsten, the fluorescent lamp records blue and the tungsten light is rendered as white.

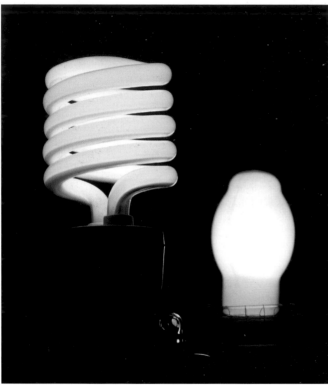

In each photo of this series, the lamp on the left is a coiled daylight-balanced fluorescent, while the right bulb is a standard tungsten lamp that produces a warmer, yellow-red light. With the camera's white balance set for daylight, the fluorescent records as white, while the tungsten is yellowish.

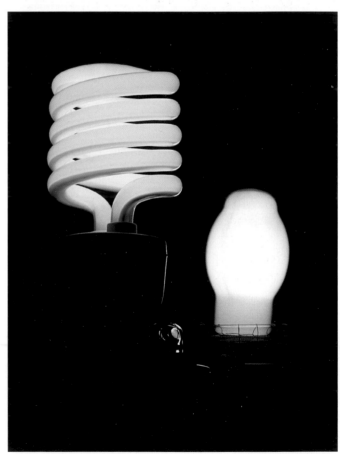

In this photo, the white balance is set to Auto (AWB). Note that neither light is white because this is a compromise setting that doesn't correctly balance either light.

Like other automatic controls, Auto white balance (AWB) makes the camera's setting for you, examining the existing light and selecting the white balance that it senses will best correct for that color temperature.

Digital cameras also allow you to select the white balance from a set of fixed, predetermined options. These choices usually include: Daylight (sun icon), Cloudy (cloud), Open Shade (side of a house), Flash (lightning bolt), Tungsten/Indoors light (light bulb), and Fluorescent (a fluorescent tube). Many cameras include a Manual white balance, perhaps called other names like Custom or Preset, which you can set up yourself. The camera's instruction book will detail the procedure for doing this if it is an available option.

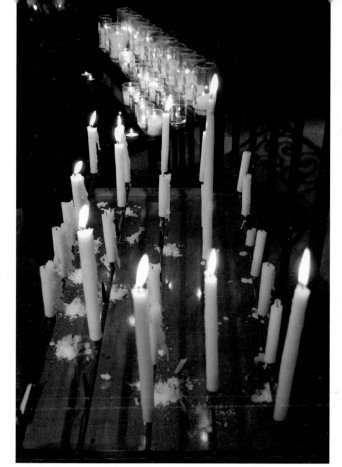

A lot of candles were required to provide enough light to allow me to take this hand held photo.

Quantity

A theater spotlight is thousands of times brighter than a flashlight. And while there's a great deal of light on a sunlit beach, there's hardly any at a candlelight dinner. And isn't that nice—dim light to enhance a romantic mood. So quantity, naturally, is about how much light there is in the scene. The range that we ask our cameras to manage, from the bright output of the sun to the dimness of a single candle, is huge.

Quantity is important to photographers because every camera's sensor requires a specific amount of energy to produce a correctly exposed picture. The aperture and shutter controls are used to let just that amount of light reach the sensor—no more and no less.

When there's lots of light, it's easy to take pictures. Outdoors in sunlight, the aperture and shutter controls only have to limit how much light reaches the sensor to avoid overexposed pictures. The tricky stuff happens in low light. Whether you are shooting indoors, at dusk, or at night, when there is a reduced quantity of light, you have to adjust to the use of flashes, tripods, and other clever techniques to make good pictures.

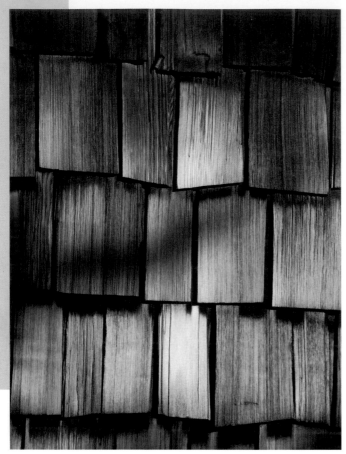

Hard light gives dimension and interest to this simple image of cedar shakes.

Quality

Light can also be described by how hard (harsh) or soft (diffused) it is. Between harsh and diffused light is a wide gamut of qualities that you can use to give shape and texture to your images.

Hard Light

Sunlight on a snowy field is harsh, causing us to squint in the glare and reach for our sunglasses. No matter what angle it comes from, it is direct, not diffused. There is a lot of contrast, creating bright whites and very dark shadows. On the beach or ski slope, you can actually see shadows that are sharply edged.

Harsh or hard light is the light of form. Its strong shadows emphasize texture and shape. If you want to show the texture or shape of something, use a hard light source or shoot on a bright, contrasty day. But be careful when it comes to photographing people with hard light, because it makes every mark, wrinkle, and scar on a person's face look deeper and more porminent.

Soft Light

On a rainy or overcast day the light is soft. There's no glare from shiny objects; shadows are faint, if not absent. Diffused light seems to come from everywhere, with no specific direction. Fog is an extreme example of diffused light. Rays of light bounce off droplets of moisture and the fog seems to actually glow softly.

When you take a picture, all of the aspects described above come into play. Good photos are the ones that best match these properties of light to the subject. If you keep the qualities of light in mind, you'll see how easy it is to use them in communicating something about the subject.

A summer downpour diffuses the daylight in this image of a tarp placed on the infield at a ball game during a rain delay, reducing contrast and lending atmosphere to the scene. © Kevin Kopp

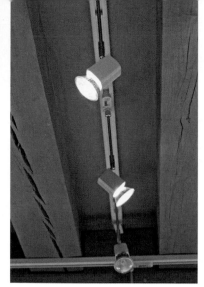

Quartz-halogen track lights are highly efficient tungsten lamps that produce a warm light. For accurate white balance, use the Tungsten setting.

Tungsten

Thomas Edison patented the incandescent lamp before the turn of the 20th Century, and today's tungsten lights are very much like Edison's early ones. The bulbs create light by passing electricity through a wire filament to make it glow. This burning wire produces a light that is colored yellow-red, even though our eyes and brain will see it as white. Tungsten lights are called continuous lights because they continuously produce illumination, unlike the very brief burst of a digital camera's flash.

Artificial Light

Along with natural daylight, artificial light is the other source of light in our lives. From the light of a campfire to the blaze of spotlights, humanity loves to shine light into the darkness.

We are most often aware of the yellow color of tungsten bulbs at dusk, when indoor lights are seen against the blue of evening light. When working with tungsten house lights or large photo floodlights, set your digital camera's white balance to Tungsten (the light bulb icon). The camera will then adjust for the yellow cast of tungsten lights, and the colors in the picture will be accurate.

With the camera's white balance set to Auto, it chooses a setting that is a good compromise for all the different light sources in this scene—fluorescent, tungsten, and natural light at dusk.

Note: The white balance setting on digital cameras is a great tool. However, white balance controls cannot always correct color temperature in mixed lighting conditions. This is one of the reasons indoor party pictures can look weird—the camera can't decide which light source to neutralize; for example, the indoor incandescent lamps or the natural daylight that may be filtering into the house.

Fluorescents

In a fluorescent tube, electricity passes through a gas, causing the gas to glow and produce light. Most fluorescent tubes emit light that is either green (standard tubes), pink (warm fluorescents), or blue (daylight fluorescents).

Although in real life our minds tend to interpret light as white, normal fluorescents lamps produce a greenish cast above that the camera will record if not corrected.

Store displays like this one are often lit by different types of lights. This store used warm fluorescents and halogen spotlights.

Offices, warehouses, stores, and schools use fluorescent lights, although you'll often find a mix of different types of fluorescent tubes in use. This produces an assortment of light colors that can look odd in pictures, and neither the white balance control nor an image-processing program can fix it. The best solution when shooting in these conditions is to use your camera's flash to override the existing light.

Because tungsten lights use a lot of electricity and contribute to growing concerns about global warming, manufacturers have responded by developing energy saving lighting devices. These new lights turn Edison's hot-wire bulb into low-watt, high-efficiency lights called compact flurescent lamps (CFL). Producing a softer light than traditional tungsten bulbs or your camera's electronic flash, they consume very little electric power. Used in reflector housings like those sold for work-lights in hardware stores, they become simple and inexpensive lights for photography.

Make sure to buy "daylight balanced" coiled fluorescents for picture taking. These bulbs match the color temperature of the daylight that streams through your windows, so you can set your camera to Daylight or Auto white balance to get accurate colors even when mixing these fluorescents and daylight. This makes simple portraiture and object photography a lot easier. Care should be taken not to break these bulbs because they release mercury into the environment.

The Colorful World

When we discussed color temperature (see page 22), we mentioned that white light is composed of all the colors in the visible spectrum. But how do we see individual colors? The color of a material object is due to the way it reflects light. For example, a blue object is blue because it reflects most of the blue portion of the white light that falls on it while absorbing other colors.

The world is a colorful place, and fortunately for photographers, color has impact and stopping power that grabs our attention. It conveys emotional qualities and creates the mood of a picture. So, think about the role color will play in your interpretation of the subject before you shoot an image.

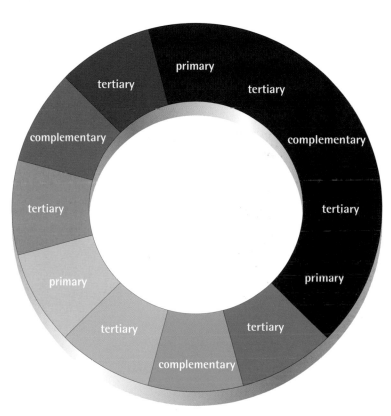

Taken from Designer's Color Manual by Tom Fraser and Adam Banks © The Ilex Press Ltd.

Shooting Color

The color wheel above is one way of thinking about the color of objects. There are three primary pigment colors: red, yellow, and blue (different than the red, green, and blue primary colors of light). These are the pure pigment colors that can't be made by combining any other colors, but all other colors can be made by mixing these three primaries together in various combinations.

Opposite the primary colors on the wheel are their complementary colors: the complementary color for blue is orange; for red it's green; and for yellow it is violet. The complementary color of each primary color is made by mixing the other two primary colors. For instance, green, the complementary of red, is made by mixing yellow and blue.

The colors on the wheel adjacent to each primary color are known as tertiary colors and they create the "color palette" for that primary. Colors within the tonal range of each palette are not high contrast and often create a similar emotional feeling within the viewer.

Red: This is a fiery color. It shouts hot and draws our eyes away from every other color. Particularly when placed against black, it jumps out of the picture and grabs the viewer.

Orange: Not as hot as red, it is mellowed by its yellow component.

Yellow: Pure yellow is the brightest of the primary colors. It is a warm, sometimes hot color that even shines against white. It's a color that in our culture is associated with happiness.

Blue: Blue is a passive color, cold and distant.

Green: The complement of the fiery red is green, the color of vegetation. It's a soothing, quiet color that contrasts well with red.

Violet: Violet is the darkest of the colors and is the complement of yellow, which is the brightest. Violet is an elegant color that is often associated with royalty.

Red and green are complementary colors that work well together in this picture.

Always be on the lookout for big areas of color in the scene you are about to photograph. The orange curtain and the orange walls would have been too monochromatic but for the area of blue, orange's complement.

A little red gives this basically black and white image its impact.

For pigments, white is the absence of color, while black is a mix of all the primaries, and gray a mixture of white and black. Mix white with the primary colors and it dilutes them, making them less bright. Black, on the other hand, darkens and enriches colors, making them more subdued. White and black affect the brightness and contrast of a photo. A picture with predominately white and light colors has a bright feeling. The more black and dark tones within, the more somber the picture.

Sometimes you can take pictures of things just for their color. Color itself can be the subject of the picture. Look for color before you shoot, and when you find a color, pull it into the frame and compose to eliminate other, extraneous colors.

I always look for rich saturated colors, and sometimes find them in the most ordinary situation.

The ribbons work together because they are all warm colors. Also take a second look at the picture of the leaves that open this chapter; they are an example of warm earth tones.

Palettes

We've all seen an artist's palette, that board with colorful dabs of paint. Those dabs are chosen by the artist because of the way they look with each other, but their selection also limits the colors in the painting to this specific portion of all color. Focusing within a certain color range is a way to make the picture more compelling and to give it more emotional impact. You can do the same thing with photography by limiting the range of colors in your photo. Do this by looking for scenes that contain a set of hues similar to colors that are next to each other in the color wheel.

The Warm-Tone Palette: The colors in the red to yellow part of the color wheel are associated with warm feelings. A subgroup of the warm tones is earth-toned colors (such as brown, ochre, and sienna), which are similar but less intense. It's the palette of an autumn day.

The Cool Palette: The colors between blue and green are the cool tones. When used alongside white, these colors become even colder. This is the palette of the seashore or an arctic day.

The cool blue and green colors make a good combination and are given added emphasis by the complementary orange in the sailor's coat

The Great Outdoors

Part of the fun of photography, be it street scenes, landscapes, or sports, is the opportunity to get outdoors. Whether photographing a beautiful mountain range, animals from a distance, or close-ups of flowers, there is an endless variety to the kinds of photos you can take outside.

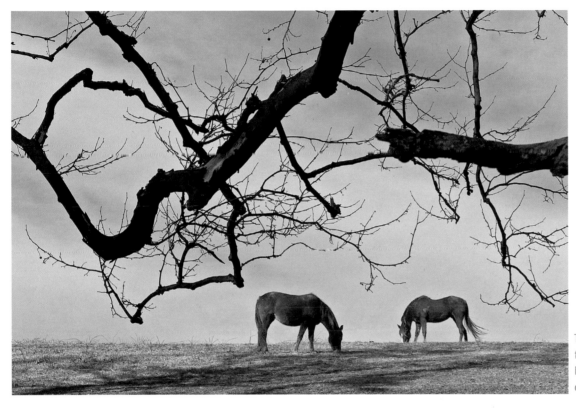

Taking your camera with you to find photo opportunities in natural light is a great way to enjoy the outdoors. © Kevin Kopp

Consider the type of camera that will best fit your outdoor needs. Point-and-shoot and EVF cameras are compact and lightweight, making them great to carry on a trip or when taking a hike. If your goal is to shoot photos that are big enough 8 x 10 inches (20 x 25 cm) for use as wall prints, you'll want a camera with a resolution of at least 6MP, maybe even higher. You'll usually get best image quality by using a good zoom lens on a D-SLR with its increased set of features and physically larger sensor with high resolution.

And also consider your flash, whether a built-in or external unit. Flash is not simply for shooting pictures indoors, but can be very useful outside as well.

Using Flash Outdoors

Why use flash outdoors? It seems counterintuitive because there is already a lot of light outdoors, isn't there? Well, yes there is a great deal of light outdoors, but sometimes it's not where you want it, and those are the times a flash can rescue a picture.

An electronic flash is like having extra light in your pocket. You can take it out when it's needed to control contrast by adding light to soften shadows. Other times, like at dusk or with a backlit portrait, your flash can add a bit of light to brighten up a subject or to put catch-light—a reflection of the light source, like a sparkle—in a person's eyes.

Most digital cameras have built-in flashes that work with the camera's metering system to produce correctly exposed pictures. There are usually several different flash settings, or modes. Because the built-in flash is part of the camera, it provides a simple and convenient way to put a little extra light into a picture. In the camera's AUTO Exposure mode, the flash is automatically activated when the camera detects insufficient light for a photo. You may have to select Force Flash (often a lightning bolt icon) or Fill Flash mode to make your built-in flash fire in typical outdoor conditions.

At full power and at short distances from a subject, even outdoors, the built-in flash can be the main source of light and will expose the photo accordingly. However, the flash on most cameras has a limited range. Beyond a dozen feet or so (3.6 meters), it is usually too weak to light an object. So it has no effect on subjects like rivers, mountains, and houses. But that doesn't mean it can't be useful in outdoor shooting.

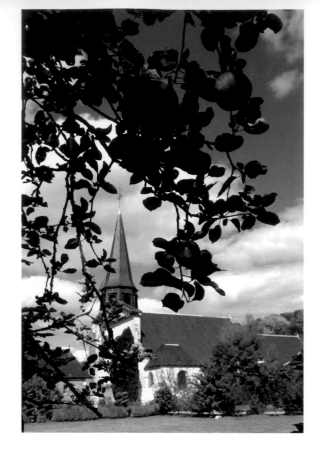

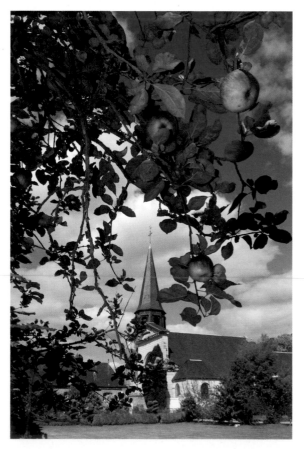

For example, Normandy, in France, is known for its apples, and I wanted to frame this small church (opposite page) with the branch of a nearby apple tree. However, the apples were in the shadows and way too dark in the first photo (top). But using the built-in flash to light the apples, I took a series of images, setting the flash to full, half, and one-quarter strength. This best photo was the one shot at half power (bottom).

Note: Many digital cameras have a button (lightning bolt icon and +/–) or a menu page that allows you to adjust the power output of the flash. Reducing the flash to use only a portion of its power allows you to keep bright areas of a picture from being totally overexposed.

Fill Flash

When the flash isn't the main source of light, it is a fill flash. This can increase the quality of your outdoor pictures. Try using your digital camera set to its Fill Flash mode if your camera has one. This will enhance the picture by reducing the depth of existing shadows and creating catchlights in people's eyes. You will want the fill flash to be less powerful than the main light source. You can do this by moving back and zooming the lens, or by using minus Flash exposure compensation if offered on your camera.

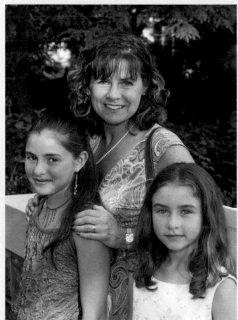

© Kevin Kopp

Back lighting (above) is evident by the rim of light around the cone, while the built-in flash was used to light the cone itself. In the picture of the mother and daughters (left), the Fill Flash mode was used to soften shadows on the faces and add catch lights in the subjects' eyes.

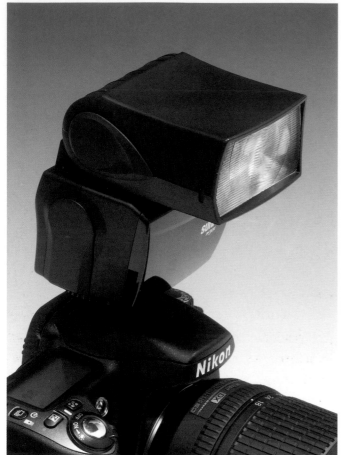

An accessory flash adds much more light than the camera's built-in flash and doesn't drain the camera's battery.

Accessory and Off-Camera Flashes

Accessory, or external, flashes that mount on your camera can radically improve your photography. They help you control the light to make more natural looking pictures. They are much more powerful and sophisticated than built-in flashes and, because they have their own battery power, they don't deplete your camera's battery. As a bonus, accessory flash units are far less likely than built-in units to produce red-eye because they are farther from the camera lens.

Some larger P&S cameras, many advanced EVF cameras, and most D-SLRs have a hot shoe on their top deck where you can attach an accessory flash. The flash unit should be "dedicated" to your particular camera brand and model, meaning the number and arrangement of the contacts on the foot of the flash exactly matches the number and arrangement of the contacts in the camera hot shoe. This insures that all the automatic exposure functions will work with the flash. These contacts make it easier to control the flash output to get the correct exposure.

Note: The phrase TTL metering means "Through The Lens," a system used by all D-SLRs. A sensor inside the camera measures the light transmitted by the lens so the camera can expose the photo properly. With TTL metering for flash, the camera controls the amount of light from the flash by measuring a series of preflashes. This is usually called D-TTL (Digital-TTL flash exposure control). The flash unit and the camera must be dedicated for this to be effective; non-dedicated flashes and studio flashes can be used with digital cameras too, but generally all the automation and D-TTL exposure control is lost.

Most accessory flash units accept light modifiers, which can also be used to soften the flash's light. From simple light paddles to snap-on domes to handmade paper reflectors, each device reduces contrast to alter and soften the light, thereby improving its quality.

A number of accessory flashes can be positioned off the camera wirelessly, or with a cable that connects them to the camera while maintaining system dedication. Holding the flash at arm's length from the camera, or mounting it on a flash bracket several inches from the lens, reduces the probability of red-eye. Photos are improved when the light is moved away from the lens so it strikes the subject at an angle better illuminating the texture and shape of subjects.

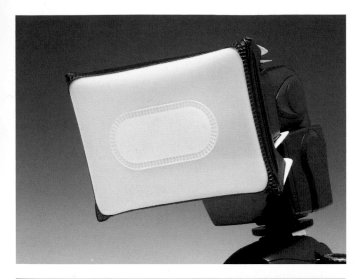

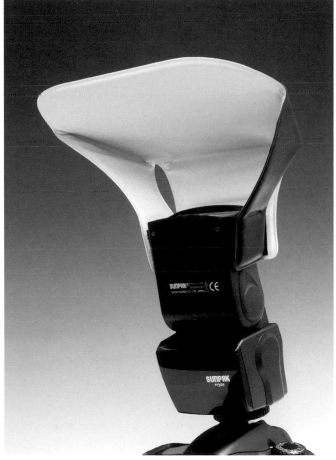

Simple light modifiers like softboxes (top) or reflectors (bottom) let the photographer soften the flash's light for more pleasing photos.

Remote Flashes: A remote flash is simply a flash that is not connected by a cable to the camera. A light sensitive photocell (or a radio control system) fires the remote flash when it senses the camera's attached flash firing. It allows increased control of image quality because one flash lights the subject (producing the highlights) and the other softens shadows.

Many D-SLR systems offer sophisticated dedicated wireless systems that support multiple flash units and camera TTL metering.

ISO and Flash

The light from electronic flash units diminishes geometrically as it travels away from its source. This means the light from a flash is only one-fourth as intense when four feet (1.2 meters) from its source as it is at two feet away (.6 meters). By increasing your camera's ISO setting, you can increase the range of light from your flash unit.

Since the boy above was approximately 25 feet (7.6 meters) from my flash, you can imagine that the light that was reaching him was not adequate with the ISO set to 100 (top). By increasing the sensitivity to ISO 200 (middle), and then to ISO 400 (bottom), I was able to get a usable image, although at ISO 400 digital noise begins to be visible.

Lenses

Other than D-SLRs, most digital cameras have a zoom lens with continuously variable focal lengths. This is useful because it gives a number of choices from which to view an image (single focal length lenses limit you to one angle of view). D-SLRs offer a great deal of flexibility because you can change lenses at any time with the ability to use a wide variety of types and focal lengths.

Lenses with a wide zoom range are a treasure for outdoor photography. Landscapes are best done with wide-angle focal lengths that can encompass the breadth of a scene, while tele-photo focal lengths are handy for reaching out and isolating some element in that scene, like a bird or a deer. And of course, a zoom lens with good close-up capability lets you take a photo like the inside of the flower on page 44.

I turned the camera to shoot vertically using the wide end of the zoom range. A wide angle takes in a large view, and as seen in this image–distorting per–spective, makes close objects appear much bigger than those farther away.

I use my P&S zoom at its widest angle to convey the sweep of the scene along the French coast of the English Channel.

In the middle of the typical zoom lens' range is a setting that provides a normal perspective.

At the long end of the zoom range are the lens' telephoto settings. Acting like a telescope, a long focal length compacts space and is great for filling the frame with distant subjects.

Daylight

Natural daylight has always fascinated photographers in all its variations. But shooting outdoors can seem overwhelming. After all, how can you squeeze the magnificence of the Grand Canyon onto a 15-inch (38 cm) computer monitor or a 4 x 6 inch (10 x 15 cm) print?

The secret is to wait for the light to be exactly the way you want it before raising the camera to your eye. For example, at noon the sun is directly overhead, which creates a strong but flat light. Even the Grand Canyon will look duller under those conditions compared to other lighting options. Plan to shoot in light that offers more interest, perhaps at dusk, photographing the same scene by the light of a flame-red sky.

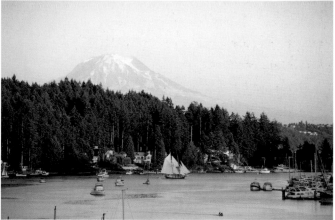

Shooting the same scene at different times of day produces entirely different colors. Knowing this fact helps you choose the best time to make a picture of your particular subject.

In this section, we'll examine some basic techniques for making better daylight pictures. Being aware of light, you don't have to wait for a sunny day to take photos. But you do need to understand the way light appears in different weather conditions, and how to use it for making remarkable pictures.

Sunny Days

When the sun is shining, it is best to use your camera's lowest ISO setting and to set the white balance control to either Auto or Daylight. Time of day is important, because the sun during the middle of the day, due to its position in the sky, produces a hard quality of light that can create unpleasant shadows. The two best times to shoot outdoor pictures during daylight are in the morning, from about an hour after sunrise till around 10 A.M., and in the afternoon, between 3 P.M. and an hour before sunset (the time frame to capture the colors of sunrise and sunset are a little different, see page 52). During these two windows of daylight, the sun is actually coming slightly from the side. This produces angular shadowing that gives texture and shape to subjects from faces to flowers to mountains.

Tip: One of the first things I learned as a young photographer was to keep the sun behind me and over my shoulder when taking pictures outdoors. When the sun is in that position, you will get the richest colors and the bluest skies.

It's best not to shoot into the sun so you can avoid such problems as glare and washed-out color or texture. Of course, there are always exceptions. Sometimes you can get beautiful color tones and back lighting by taking a picture of the sun just above the horizon as it sets.

In this photo of the river at sunset, I waited until the sun had slipped behind the trees to avoid having it overexpose a section of the image.

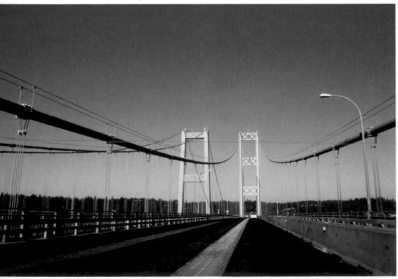

Shooting with the sun low in the sky to the left helped bring out the details in this shot of the two Tacoma Narrow Bridges.

Camera Support

Shutter speed is a key component to insure sharpness and clarity of your photos. If it is too long, your pictures may exhibit blur from camera movement. You'll have to determine how steady you can hold your camera by experimenting to find appropriate minimum shutter speeds when shooting at different focal lengths.

Using image stabilization (IS) or camera support can further improve the sharpness of your photos. IS systems reduce the effects of camera shake during exposure, but they have their limits, one of which is shutter speed: These systems cannot eliminate all of the blur at speeds longer than 1/15 second. There is nothing as effective as an accessory camera support to make the sharpest possible pictures.

The best camera support is a solid tripod that provides a stable shooting platform supporting the camera at the photographer's eye level. Tripods come in a myriad of sizes, weights, and prices. Selecting one depends mostly on the size and weight of your digital camera. You'll need a large, sturdy model for a D-SLR with a long telephoto lens.

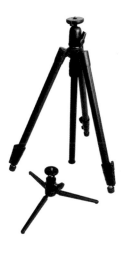

An alternative to a full-size tripod is a mini-pod; a scaled down tripod that weighs only a few ounces and easily fits into a pocket or camera bag. Mini-pods can also be used as "pistol grips" for sharper pictures. Just close the legs and screw the mini-pod into the camera. Grasp the mini-pod in your left hand while holding the camera body with your right hand.

The JOBY GORILLAPOD® is an unusual mini-pod with flexible legs that function both as tripod legs and as clamps. You can wrap the legs around a pole or a tree limb and create a secure support.

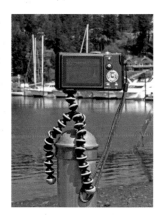

Another type of support is the monopod, a single tripod leg that is extended to support the camera at the photographer's eye level. A monopod can't stand on its own; it requires the photographer to supply the two legs that are missing. They are useful for action photography when you don't have time to set up a tripod.

Finally, there are beanbags and camera clamps. You can use a beanbag by placing it on a surface and nestling the camera into the soft bag. Clamps come in several types, but all have a tripod head where the camera is mounted while the clamp is attached to a car window, tree, or some other solid object for support.

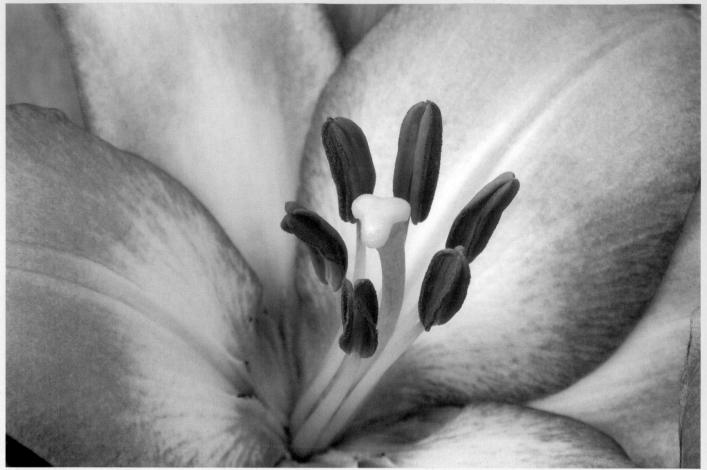

Shooting close-ups is often a balancing act. You want a small enough f/stop (larger f/number) to insure adequate depth of field, but that may mean a shutter speed too long to prevent camera shake. It is helpful to use a tripod or the camera's image stabilization system (if it has one). Using the camera's built-in unit for fill flash can also help.

Flowers

Flowers can often be successfully shot with the camera set at a low ISO while using AWB and AUTO Exposure mode (or Aperture Priority mode if you want to control depth of field). Individual flowers look wonderful when backlit and photographed against a simple, dark background. Get close enough for the blossoms to fill at least half to two-thirds of the frame. With the sunlight coming from behind, petals light up and the edges of plants glow. But don't always wait for sunlight—I also like to shoot flowers under the softer light of an overcast day. And don't forget to take several photos from a number of angles. It's amazing how different a flower will look simply by changing the point of view.

When shooting midtone or dark flowers against dark backgrounds, you'll often need to use the exposure compensation control. Try one or two stops of underexposure (-1 or -2) to get rich, saturated colors.

Wind can be a problem when photographing flowers outdoors, causing a blossom to shake and bend in the slightest breeze, which will make a blurry picture. Neither built-in image stabilization systems nor a good tripod will help since they don't solve the problem of subject movement. To solve this problem, either wait for the breeze to settle down or position yourself so the wind is to your back and blocked as much as possible by your body.

Shooting flowers under soft light in overcast conditions helps you record detail in the lighter tones.

A wireless remote flash can come in handy for flower photography (and many other objects). Turn the built-in flash on and position the camera in front of the flower, placing the remote flash to the side and closer to the subject. When you snap the picture, both flashes will fire. Experiment with the remote flash's output settings until you get the picture quality you want.

Gardens

Naturally light plays a very important role when photographing gardens. The look of a garden on a sunny day can be wildly different than the look of the same garden under an overcast sky.

When the sun is shining, walk around the garden before photographing to see how the relationship between the colors and the foliage changes with the direction of the sunlight. When the sun is behind you in a front lit situation, there are few shadows and the garden may seem flat and two-dimensional. It's better to alter your position so sunlight is coming from the side, which is effective for garden photos because it adds texture and a three-dimensional quality. This way the shape of the elements in the garden are separate and stand out from one another and colors are enhanced.

Tip: As you move around the garden and view it from different angles, notice how certain plants look better than others as the light shifts and your perspective changes. Keep in mind that small areas of bright flowers will easily overwhelm and dominate large areas of dark vegetation. Look for color contrasts and see how different framing affects their interrelationships. Try to include other elements of the garden, like arbors and fences, to give the garden scale. Make sure that you look at the garden carefully before you shoot, paying attention to dead or broken plants, so that you keep them out of the picture.

Back lighting is particularly wonderful in a garden photography. When you are facing the sun, you'll see that flower blossoms, because they are so delicate and translucent, will light up and glow. To accentuate this effect, it helps to frame subjects with darker foliage behind the blossoms.

On a sunny day you may find that your camera will properly expose dark foliage at the price of overexposing the light or white blossoms. When shooting a garden with lots of green foliage, I set the exposure compensation control to –1 or –1.5 so that the foliage is dark and the light blossoms are not washed out.

On an overcast day, the diffuse nature of the light reduces the contrast between the dark foliage and lighter plant blossoms. This gives the garden a softer look and, with certain combinations of plants, may work better than shooting in bright sunlight. This is especially true when photographing masses of white and light blossoms. Diffuse light means more detail in the blossoms and more saturated colors.

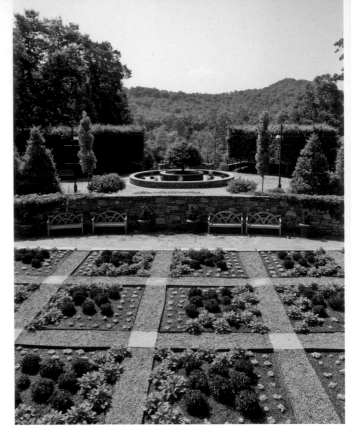

Consider the overall pattern and color when setting up to photograph a garden. © Kevin Kopp

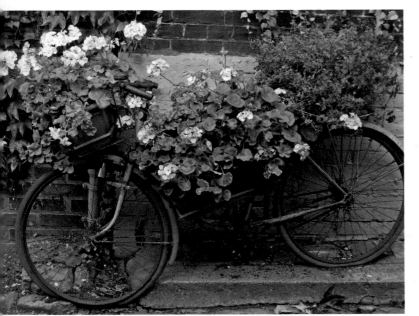

This "bicycle garden" illustrates the advantage of shooting flowers and gardens in the shade or on overcast days. The light's lower contrast makes it easier to capture a long tonal range from white blossoms to dark leaves.

Patterns of color and contrast are also very important when photographing gardens. A garden is like an abstract painting, so composition plays a key role. It's often the overall arrangement of the flowers rather than the individual ones that create pleasing masses of color. Framing the garden to show these arrangements is a significant part of the job.

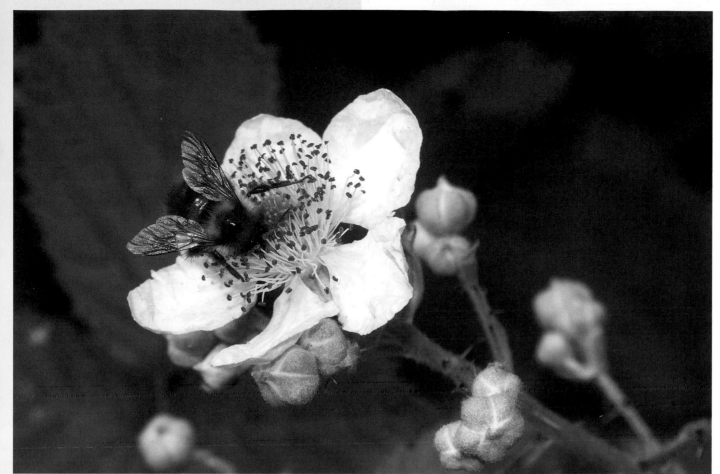

Insects move around pretty fast, so I raised the built-in flash to help "freeze" the action as this bee flew from flower to flower.

Insects

The photography of insects requires a close-focus or macro lens. Most digital camera zooms have a close-up (or macro) setting that allows you to focus within a few inches of the subject. Experiment with your camera to learn how to set and use the lens at its macro setting.

It is important when shooting close-up to be aware of the light's direction and to make sure to keep the shadow of the camera out of the picture. Also, camera shake is exaggerated at macro distances, so you need to turn on the image stabilization or use a tripod.

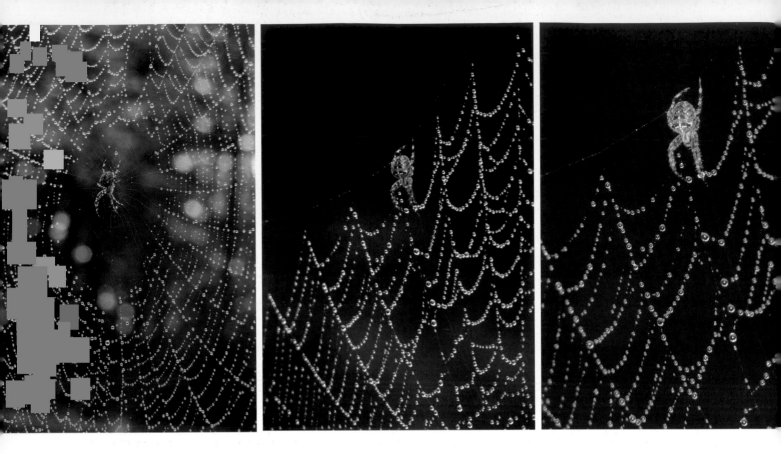

The camera's built in flash comes in handy for shooting insects. The three photos above show the effect of controlling the flash intensity. Without the flash (left), the spider's web and the background are equally lit, with the web getting lost in the background. However, with the flash set at a fraction of its full power the background is now darker (middle). Using the flash at full power, in AUTO mode the camera ignores the background, which goes quite dark, leaving the web brightly lit and jumping out of a dark background (right).

Rainy Day Blues

Bright, sunny days evoke feelings of happiness, but I like shooting in poorer weather too. Since days with inclement conditions are often darker than normal daylight, it is helpful to increase your ISO setting to 200 or 400, and set your white balance on Cloudy (or take a manual reading).

From light rain to skies that are dark and foreboding, bad weather is moody and can add interest to your photographs. The trick is to use the moodiness to relay something about the subject. For example, if you were on a seaside coast during inclement weather, a picture of empty boats moored in the rain would probably give a sense of loneliness; or a lighthouse would have added meaning since its purpose is to guide ships through storms, making it a great subject for a cloudy, gray day. And don't overlook urban landscapes that burst into colors when neon signs and streetlights are reflected in the wet city streets.

Fog and Haze

Fog occurs when drops of water cling to dust particles in the air. This is interesting from a lighting perspective because sunlight is randomly reflected in many directions when it hits these drops, becoming totally diffused. The dispersed sunlight can create beautiful effects and adds a

The autofocus may not function effectively when shooting a featureless surface like a plain wall or a thick fog. That's because an autofocus system usually needs subject contrast in order to focus. I switch to manual focus when I encounter these situations.

sense of both sentimentality and mystery to photos. The speckling of fog in a photograph creates a painterly quality reminiscent of French Impressionists. You can control the grayness of the fog by adjusting the white balance control, resetting it to Cloudy if the fog records bluish when using Auto WB settings.

Snow Scenes

The trick to shooting snow scenes is simple: Use the exposure compensation control and set it to +1 or +1-1/2. That's right, you want the camera to add exposure to the picture. This is because the camera's meter sees all the glare from the white snow and it overcompensates, making it neutral gray. The result is a dark picture and gray snow. Using the exposure compensation brings the whites back. Experiment with white balance settings when photographing snow. Choosing the tungsten setting will add blue to the photo, adding a striking cold look.

Exposure compensation of +1 was needed to produce white snow in this shot

Filters

There are hundreds of colored and special-effect filters you can buy for you camera. They help capture the light to create dramatic images while also offering protection to delicate lens surfaces. The filters illustrated in the photos above are just a few of the kind that are the most useful in digital photography.

But why use filters with a digital camera when most of the effects of these filters can be pretty much duplicated using image-processing programs? Simple—because duplicating these effects in the computer can take much longer. It's a lot easier to use a filter and be done than to sit in front of a monitor, not shooting pictures.

The round filters in the photo (above left) screw into the front of your lens. You can get filters in any diameter to fit you camera lens. The square filters are part of "universal" systems. Special holders mount on the front of the camera lens and these filters are slipped into the mount for use. These systems allow you to use a single set of filters on lenses of different thread sizes. Special mounts like the magnetic one (top right) are also available for P&S cameras that don't have a threaded lens.

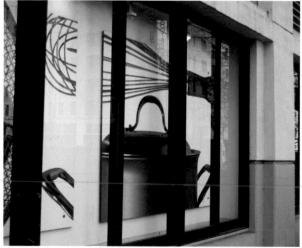

These two photos illustrate the way a polarizing filter works. Rotating the filter 90° substantially reduced the reflection of the building in the store window.

You can use colored filters to add impact and interest to your photos. I made this image using a deep orange filter over the lens.

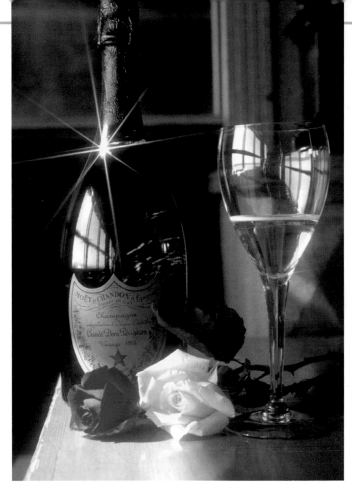

To create a romantic image with natural window light, I placed a starburst filter in front of the lens. This did the trick by producing the star sparkle—actually the reflection of the sun—on the champagne bottle.

Circular Polarizing Filter: Rotate the dark glass portion of this filter after screwing it onto your lens. It cuts reflections on shiny surfaces like glass and can help to saturate the colors in a scene. Cutting reflection and glare is something that is almost impossible to fix in post-processing.

UV Filter: This type is handy to protect the camera lens. On more than one occasion I've had a UV filter shattered by an impact, leaving my expensive lens untouched. UV filters also reduce the blue cast of atmospheric haze, seen in distant subjects.

Graduated Neutral Density Filter: These are used to balance the contrast between two parts of a scene. For example, when taking pictures on a snowy field, you can place the filter in front of your lens with the dark section at the bottom to reduce the intensity of the snow, thereby retaining detail in it.

Special Effects Filters: There are also all sorts of special effects filters that can add interest to a photograph. These include multiple image filters and prismatic filters that add a rainbow fringe to everything. There are split field filters that let you combine close-ups of objects with distant scenes. There are even filters that add starbursts or cyclone swirls to subjects, and ones that emulate the effect of a zooming lens.

The light soon after the sun rises is special and distinctive, often with a pastel hue. © Kevin Kopp

Sunrise, Sunset

Both early morning and late afternoon are great times to take pictures. Since shooting at these times may require relatively long shutter speeds, it is again advisable to use a tripod.

Morning light is soft and rosy and adds a peaceful atmosphere to pictures. It's different from the intensity and deep reds and oranges of a sunset. The best times to shoot are the moments just before sunrise or just after sunset. As the sun crosses the horizon—either coming up or going down—the sky gets especially colorful and intense.

The white balance setting will strongly affect the colors in the picture, especially when shooting at sunrise or sunset. Remember that the white balance control is trying to neutralize colors based on the color temperature of the light source. Since the light at dawn or dusk is yellow or red, the white balance control may try to overcompensate. The best solution is to take a few frames of a sunset at different white balance settings and see which works best. Try a few frames at the AWB, Daylight, and Cloudy settings. Or, learn how to use the Manual (sometimes referred to as Custom) white balance setting if your camera has one. This creates a white balance setting calibrated to existing light. Again, check your camera's instruction manual to set this.

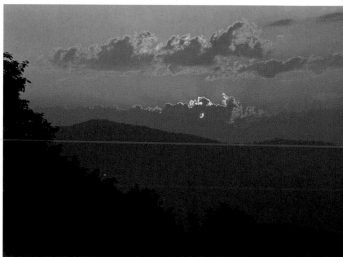

The sunset light is often quite vivid, like the orange of this summer evening in the mountains. © Kevin Kopp

Night Photography

Low light requires longer exposures times—sometimes very long. Simple P&S cameras don't offer very long shutter speeds or the ability to hold the shutter open by hand, though many do offer a Night Scene mode. But results vary, so if you plan to do a lot of photography at dusk or at night, it is best to use an EVF or D-SLR for the best results. And for all photography that requires long exposure times, there is nothing that helps as much as a tripod or other camera support.

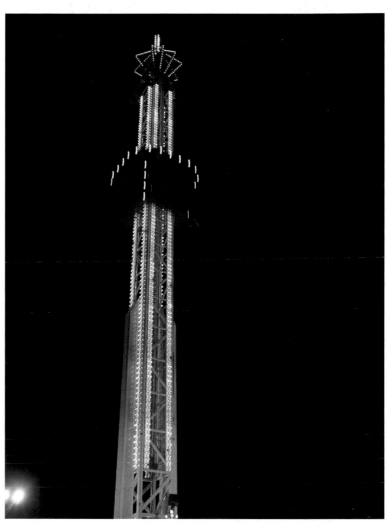

The subject of this shot is obviously the colorful lights of a carnival ride and the way they contrast with the black night. The gondola around the light tower is falling toward the ground and its motion is blurred because the shutter speed is too long to freeze its movement. © Kevin Kopp

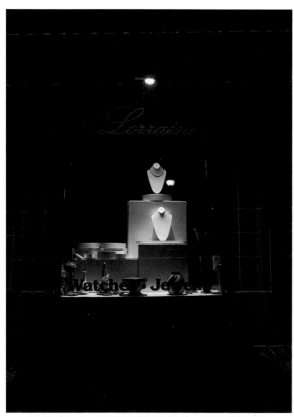

The lit display in this jewelry shop window contrasts with the darkness of night during a misty rain (which you can see surrounding the spot light in the top center of the picture). The ISO was set to 100, so the photographer manually set the exposure and tested until getting the desired balance between light and dark. Again, use a tripod when shooting in low light. © Kevin Kopp

Image stabilization is usually required when shooting at dusk. Be aware of your ISO setting and shutter speed when shooting in low light, because both can affect the level of digital noise in your picture.

Noise

Generally, digital cameras don't record well in relative darkness because low light usually requires long exposure times—sometimes very long—and that heats the sensor, causing noise, even with D-SLRs. Additionally, when your camera is turned on, electric current passes through the sensor, creating electronic "noise." Each pixel needs this tiny bit of energy to work. When lots of light from the lens strikes the pixel, the noise is so weak in comparison that it is unnoticeable. But in low light, and when the camera is set to a high ISO, this noise becomes visible.

Noise is more visible on a computer monitor when you view the image at a large size, and less noticeable in web images and prints. Noise appears as colored specks throughout portions of the image and makes lines and edges in the image soft and blurred.

Be aware that noise problems can occur whenever you are shooting at higher ISO settings, whether or not you are shooting in low light. It's there, especially with P&S and EVF cameras, so try to work with it. For me, it can be like the grain in high-speed film. But if I find I don't like the noise in a picture, I can use one of several effective noise reduction software programs in the computer to remove it.

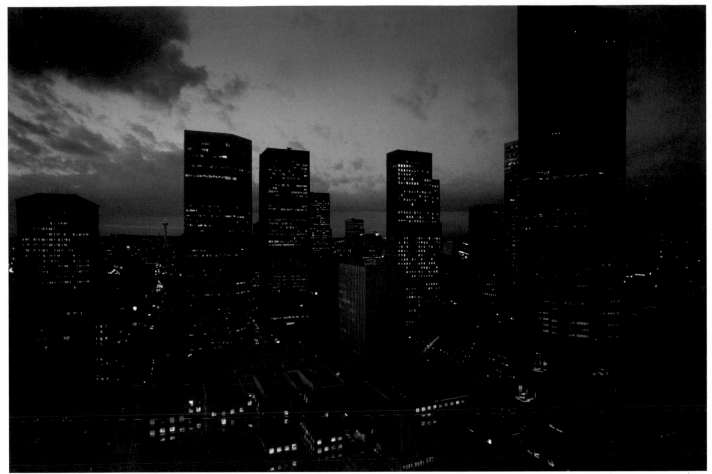

Light changes rapidly after the sun sets. Because the city buildings were dark, it was important to have a little color and light in the sky to make them stand out.

Night Shots

Is there light at night? Well, yes! Night photography creates its own special form of beauty. A cityscape is impressive because all those lights represent the efforts of people to push back the darkness. A moonlit landscape reminds us of the isolation and remoteness of the natural world at night.

Some digital cameras have preset exposure modes for night photography, or you may want to set the Aperture Priority or Manual modes. No matter what exposure mode you select, shooting nightscapes requires some source of light. Whatever you choose to photograph, whether it's a thousand stars or a skyscraper's windows, the light needs

to be your subject: Night photography is more about light than about the objects in the picture. The light reveals the objects, but the light itself is the subject.

When you are taking long exposures, brace the camera against something solid or use a tripod. It might well be helpful to set a relatively high ISO, like 400 or 800. Try the Daylight white balance setting, or experiment using Tungsten or Fluorescent for a blue or magenta effect. Compose the picture by placing the lights in critical positions—not in the middle of the frame—along imaginary grid lines that divide the frame like a tic-tac-toe screen (rule of thirds), or in an "S" curve.

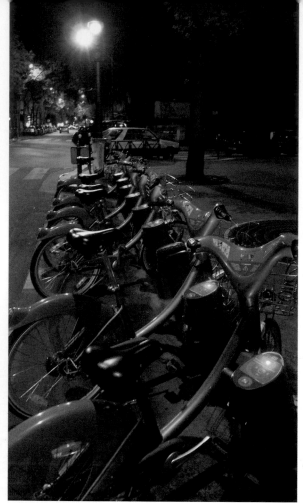

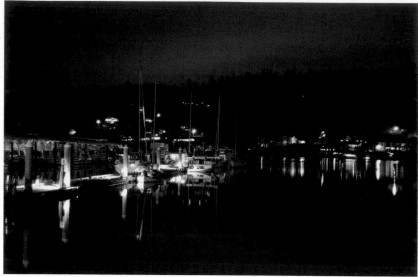

With my camera mounted on a tripod, I took this ten second exposure of boats at my town's public dock.

These bicycles are part of a public use system in Paris. I was unhappy with the photos I had taken of them during the day. At night, however, the streetlights and the lights on the bike stands add a lot of interest to this image.

Unless you are photographing people at night, there's no reason to use a flash. Its effect will either be negligible or it will destroy the night feeling of the picture. Depending upon your type of camera, you may want to set the camera in the menu to make sure that the flash won't fire.

If you do wish to include people in a night scene, you should select Slow Sync or Night flash modes, depending on your camera (check your instruction manual). Remember to make sure the people are within range of the flash. With these settings, the background should be properly exposed as a night scene.

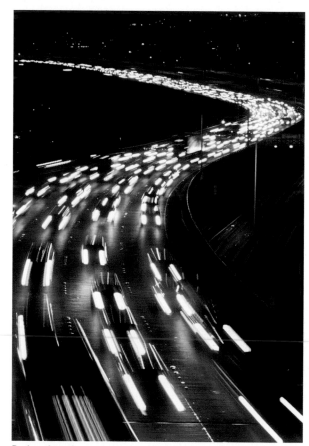

By bracing the camera on the overpass rail, I could successfully use a long exposure (1/4 second) to produce the blurring affect for the car headlights, adding additional portions of brightness to an otherwise dark highway scene.

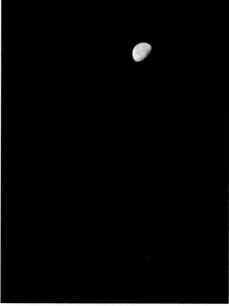

The moon photographed in the early in the morning required experimenting with the exposures to get the shot right.

Pictures of the Moon

When you photograph the moon at night or in the early morning, the sky will be dark and your camera may tend to overexpose the picture. In this case, it is a good idea to either shoot in the Manual Exposure mode and deliberately underexpose, or use a minus exposure compensation factor (perhaps -2 stops).

The best time to shoot the moon is when it's just above the horizon, right after sunset or before sunrise. You want the sky to be dark but not black. Setting the camera to underexpose will make the sky look even darker in your photo, so shoot when there is still some light in the sky.

To figure out the proper exposure, start in Manual Exposure mode and set a baseline. For example, take a photo with the camera set to f/5.6 at 1/60th second with 100 ISO. Depending upon atmospheric conditions, this is probably a good first shot. This shutter speed is too short to record stars, but you will most likely expose a bright moon that shows surface features. Examine the photo in your camera's LCD screen and adjust the exposure and/or ISO as necessary until you record a picture with which you are satisfied.

Tip: If you are really enjoy taking pictures of the moon, there are a number of websites that provide the date and time of the full moon and its location in the sky so you can find that perfect night to shoot. Use your favorite search engine to find a phrase like "moon phase location."

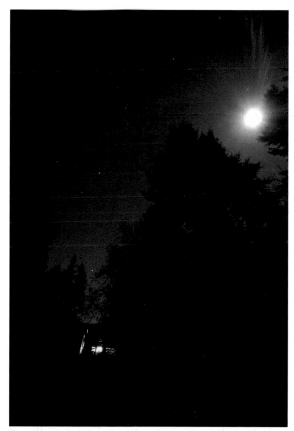

Shot late at night, the moon is so bright it appears as just a white spot. Including the house and trees helps gives this image its impact. Since the sensor accumulates light, the photo records many more stars than were visible to the naked eye.

Fireworks

Taking good pictures of fireworks is not as difficult as you might think. There are two ways to shoot fireworks: instantaneously or with a time exposure.

Let's look at shooting instantaneous pictures. It's easiest to shoot fireworks using the Manual exposure mode. Daylight white balance works well in this situation. Set the ISO to 200 or 400, the aperture to its widest setting, and the shutter to 1/30 or 1/15 second. Because the sky is dark and the fireworks are the only source of light, it is possible to hold the camera in your hands and shoot at relatively long exposure times without a tripod. Since the bursts are rapid, and their moving trails are spots of light, they should record quite sharply.

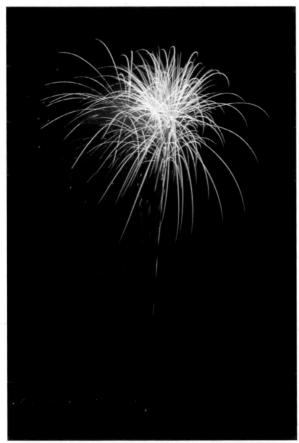

The three rising smoke streams show that three explosions occurred almost simultaneously, all captured as one large fireworks bloom with a shutter speed setting of 1/30 second.

Point the camera at the sky where the fireworks are exploding (use a moderately wide-angle focal length) and wait for a burst to begin. Hold the camera tightly and snap the picture. Check the picture review (playback) and see if you need to use a longer or shorter shutter speed or a higher ISO to get a better exposure. The slower your shutter speed, the longer the exposure time, and the longer the light trails will be in the picture.

I prefer the second way to shoot fireworks, which is the timed-exposure method. This allows me to get several bursts in a single frame, which makes very pretty pictures. Even a single chrysanthemum burst looks flat compare to a picture full of explosive colors and bursts.

Timed exposures require a different setup than instantaneous. First, set the camera on a tripod or minipod and point it where most of the fireworks are exploding. Use the Shutter Priority mode set to a speed of a couple seconds or more. (If your camera has a Bulb setting, the shutter will stay open as long as you hold the shutter release.) Now wait for the fireworks show to really get going. Listen to the explosions. When several fireworks are fired, press the shutter release. Long exposures will let you record several separate bursts in one frame, with lots of lovely, long multicolored light trails.

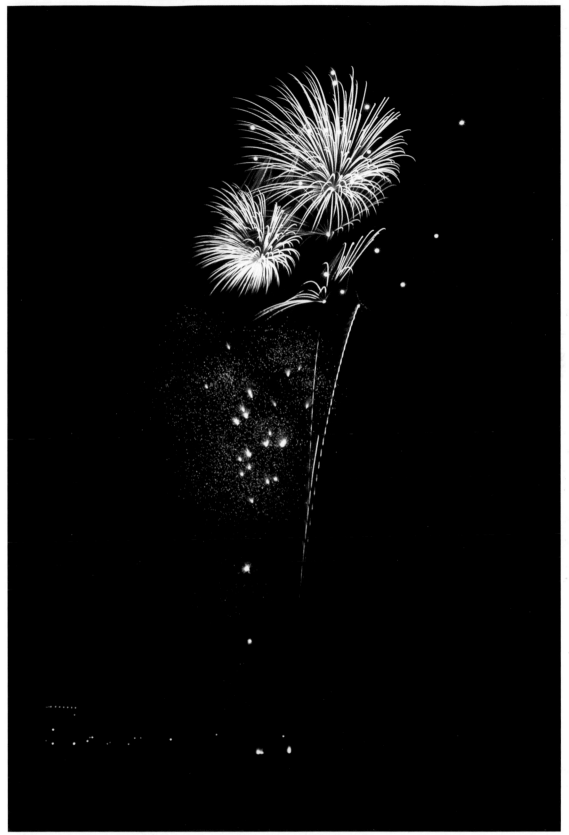

You will capture several different bursts, as well as long light trails, when you set a long shutter speed. This was shot using a shutter speed of several seconds.

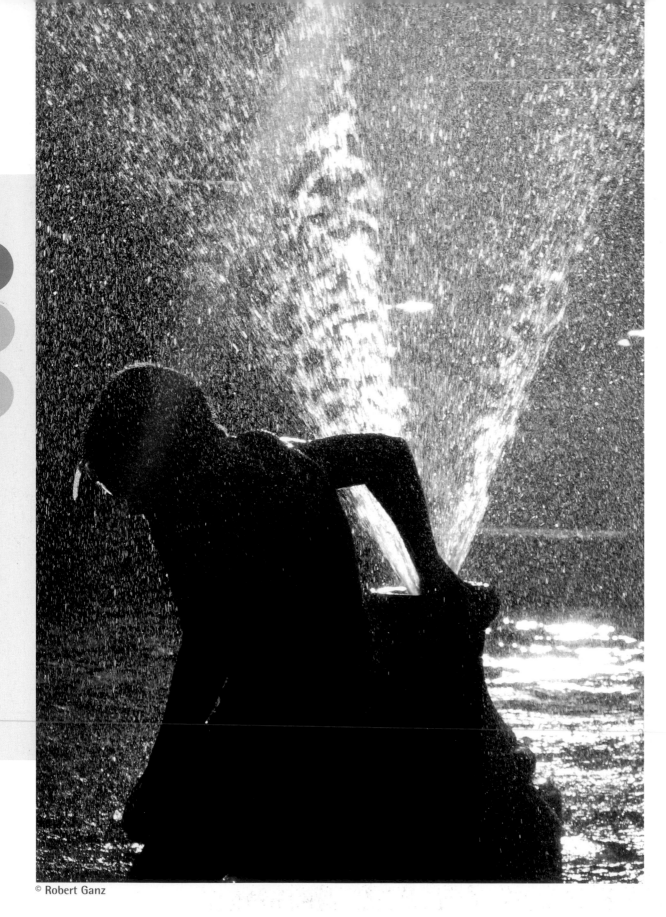

© Robert Ganz

Location Portraiture

4

The trick to photographing people outside of a formal studio, especially for candid shots, is fundamental: Observe and think before you shoot! Consider the light around your subject, and form a plan about how you want to use it. Make sure to take a moment to talk with your subjects; making them comfortable pays big dividends.

I believe too many people take pictures of friends and family on the fly. Hustling folks together, pointing the camera haphazardly and yelling, "smile," won't make good pictures. Inevitably, your uncle Fred's eyes will be closed and Aunt Martha will be frowning. If you want photographs that you will cherish, do yourself a favor: Slow down and do the pictures right.

Note: You will be taking many pictures of people indoors, so you will often want to engage the flash. With the camera set to AUTO Exposure mode, it will select a shutter speed to sync with the flash. The result is often a well-lit subject surrounded by darkness or near darkness. If you want to brighten the background, switch to the Slow sync mode, shifting the shutter speed to 1/30th or 1/15th of a second. Allowing the shutter to be open longer will brighten the background, but be aware that shifting the shutter speed also alters the aperture, which can affect the flash exposure.

When photographing two people, it's important to show the relationship between them. The best candid images occur when people forget that there is a camera pointed at them.

North-facing windows are known among professional photographers for a quality of light that produces deep colors and flattering skin tones.

Simple Tips To Get Great People Photos

1. Get Close: You want to see a person's face, particularly their eyes, in a portrait. Move close enough or zoom the lens so that their face and shoulders fill the frame.

2. Simple Backgrounds Are Best: Keep backgrounds simple and uncluttered.

3. Use Natural "North" Light: Daylight from the north is famously soft and known for producing lovely skin tones and deeper than normal colors. Painters love it, which is

why they look for studios with large north-facing windows or skylights. But you don't need a studio in order to use northern light. Simply place your subject(s) by large windows on the north side of a building. That's what I did for the photo to the left.

4. Frame Using Rule of Thirds: Don't put people's faces in the middle of the frame. Place eyes on the top third line.

5. Shoot Verticals: Turn the camera and shoot vertical images. They are often stronger for portraits than horizontal compositions.

6. Learn to Use Accessory Flash Units: With D-TTL metering, flash photography can be a creative tool to help improve your pictures in situations that are otherwise difficult. But even with D-TTL technology, D-SLR flash units can be powerful enough to blow out details in subjects close to the camera. You can avoid this problem by using the camera's flash compensation control or by setting a dedicated accessory flash to reduce its power output. Try a few settings until you get the one that lights the subject but doesn't have a harsh "flash" look.

7. Make Eye Contact: Portraits are better when your subject(s) make eye contact with the viewer of the photograph. To do this, have them look at the lens and not at the photographer, especially if you are holding a point-and-shoot camera at arm's length to frame the picture on the LCD monitor. (However, if using flash, be aware of potential red-eye.)

8. Talk to Her (or Him): Portraits reflect the interaction between the photographer and the subjects. Talk to your subjects, tell jokes, and generally try to warm them up. The more comfortable the subjects feel, the more their facial muscles relax and the better the pictures.

Placing people in rows, shorter or seated folks in front, keeps them organized and insures that no one's face is obscured. This shot in open shade could have been a vertically as well as a horizontally formatted photo, but larger groups would probably have to be horizontal. (c) Jeff Wignall

9. Take Lots of Pictures: No way around it. You need to take multiple shots to increase your chances of getting that one special portrait. There are fifty-two muscles in a face, and it takes a lot of pictures to capture the image where they are all just right.

10. Use a Telephoto Lens Setting: People look better when photographed with a lens using a moderate telephoto focal length. On most D-SLR cameras, this would be a lens with a focal length range of 50–100 mm. A telephoto lens compacts space and produces a pleasing image that can make the face look well proportioned. Because depth of field decreases with increased focal length, it also isolates the subject from the background while providing some distance from subjects, which helps them relax and also softens backgrounds.

Photographing Small Groups

Photographing two or more people can be a lot like herding cats. Chaos is always just around the corner unless you take charge. Here are some tips to make a great group shot.

Organizing the Group

For any group of five or more people, I like to make at least two rows; a single line can make everyone's face look small in the picture. The front row should be the smaller and shorter people, or ones who are sitting or kneeling. The back row should consist of the taller people. Align the rows so you can see every face.

With a group, place your subjects so you can see each face fully, and to save space you may have a few folks stand at an angle to the camera.

Tip: Whenever possible, face the group towards you so the sun is over your shoulder but high in the sky. It's best to shoot groups on an overcast day or when the sun is high in the sky and not directly shining into people's eyes. With the sun directly in their eyes, everyone will squint, moan, and not want to stay put for the picture.

Frame the group so that the faces of the front row are on a line through the center of the composition and the shoulders of the folks in the longest row come close to touching the edges of the frame. Look carefully to see if there are shadows across anyone's face—particularly check that people in the front row are not casting shadows on the folks behind them. If so, rearrange them to eliminate shadows before shooting.

If the photo shoot is completely under your control, ask everyone to wear similar clothing. Group and family shots look better if people are wearing complementary clothing. Of course this is not always possible, but be aware of white clothing or busy patterns. Whites are a problem because they tend to wash out in pictures. If someone is wearing white clothing, put him or her in the middle or back rows so the other people will cover the white as much as possible.

The photographer used an accessory flash along with available window light, and placed this large, casual group at the bottom of a stairwell so he could get up higher and look down for this photograph. (c) Kevin Kopp

Bigger Groups

With more than a dozen people, consider breaking the group into three rows. If possible, the front and rear rows should consist of an odd number of people. For instance, try dividing 18 people into rows with five in the front, six in the middle, and seven in the rear. Remember to organize people by height. It helps, too, if you can place the back rows on higher ground, stairs, or risers, or have the front row sit on chairs or get down on their knees.

Shooting a big group requires a lot of light, and professionals would use a couple of big strobes in softboxes. So for most of us, it makes sense to take everyone outside and find a large open area. Step back until you can see the whole group in your viewfinder.

With a group, it also helps to shoot from a higher than normal position, so a small ladder or step stool will be helpful. With someone spotting you on the ladder, hold your camera at or a bit higher than the mid-level of the group.

Turn the camera flash on and take a several pictures. Most built-in flashes are not strong enough to be the main light for a large group shot, but the flash can add a little light to the shadows and catchlights to people's eyes. This is another place where a powerful off-camera accessory flash really helps.

Tip: It is really frustrating to discover that one or more people have their eyes closed when you review a group portrait. The simplest remedy is to tell everyone to watch you and tell them you will take the picture at the count of three. Get them to focus on you. Count one, two, and then surprise them by taking the picture. Forget the three, because everyone expecting the flash will blink when you say it.

Get Up Higher

Try standing on a chair (held firmly by a friend) or a small stepladder to help improve group photos. Taking a group picture from above reduces the chance of anyone blocking another's face, and that perspective makes double chins magically disappear. You can also experiment with more casual photos. Try several shots where people are not necessarily lined up for the picture.

Baby Portraits

Babies are always unpredictable, and taking pictures of them requires patience as well as fast reflexes. It helps to have a camera that responds quickly with little or no shutter lag.

When shooting outside in sunlight, babies, even more than children or adults, will squint—you can't ask a baby to ignore the brightness for just a moment until you are done with the picture. So it's best to photograph them in open shadow. The light in the shade is softer, which helps to make a more pleasing picture.

I like to put babies down on their tummies so they naturally try to hold themselves up and look into the camera. This creates more of a connection than a shot of a baby lying on his or her back. Get down to the child's level and watch and wait. Give the baby a few minutes to adjust to its surroundings and to your presence. If there are other people around, have them stand quietly behind you because babies are easily distracted.

Often it works well to use a telephoto focal length. Using the Aperture Priority mode, I select a large apeture (low f/number). This limits depth of field, which softens the background and separates the child from it. Then I make sure to focus on the baby's eyes.

Babies are cute and soft, so it is usually better to photograph them with softer light than the camera's built-in flash can provide. So turn off the flash (set the camera mode to Program rather than AUTO) and use available light.

Photographing babies in natural light produces soft skin tones. But because babies are so active, using a flash can at times help you capture those precious, fleeting moments when the baby is exhibiting just the perfect pose or look. Naturally it's important to use common sense. Babies are sensitive to bright lights. If you are using a flash, you will want to set the camera lens to its longest (telephoto) zoom setting so you can stand a bit back from the child and not set off the flash directly in his or her eyes.

For the greatest success with flash, use an accessory unit with an adjustable head. If you are indoors, point the light at the ceiling to create a soft bounce light. You can also add a reflector card, mounted on the flash head, to help direct more light towards the subject. A softbox attachment is another device that you can use to soften the light for baby shots.

Another technique with an external accessory flash is to hold the unit at arm's length with your left hand up over your left shoulder. You will need a dedicated cord to maintain automatic functions.

Setting up lighting is the easy part of photographing babies; the harder part is waiting and watching. With babies, the best smiles and expressions are short-lived. So be ready and anticipate the child's actions. If you see a great shot coming, press the shutter release halfway to lock exposure and focus, then take the shot at just the right moment.

The brilliant color and back lighting of an ocean sunset help create a photo that is much more dramatic than the typical portrait of family and friends. © Jeff Wignall

Portraits at Dusk

Everyone loves photos of family and friends posed against a brilliant flame-red sunset. It helps to shoot this type of portrait during the last half hour or so before sunset, when the sky is darkened and the colors are deeper. Wait for an evening with a clear sky if you choose, but that's not necessary because a few clouds, if present, can add a touch of drama to the picture.

Unless the sun is very low, or the horizon and sun are particularly interesting, you needn't have the sun itself in the picture. Too often it ends up being a big, bright, dis-

tracting spot in the frame that draws attention away from your subjects. It can also make the scene's contrast too high, resulting in a burnt-out sky, dark faces, or both. So it is always possible to pose your subjects with the sun out of the frame if that will make a better picture.

While you may get decent results with the camera's AUTO Exposure mode, I prefer to take control of the situation. First of all, because light fades rapidly after sunset, I use

an ISO setting of at least 200, or perhaps 400, and then set the camera in Manual exposure mode to a shutter speed of 1/60 second to insure sharp hand-held pictures. Then I try various aperture settings to see which produces the best balance between the sky and the subjects.

One way to add light and better balance in this type of picture is to use a flash. While there is no hard-and-fast rule for setting the flash, a good starting point is to find the exposure that gives a good reading of the sky, and then try frames using different EV settings with flash exposure compensation. Look for the picture that looks most natural.

Parties and Events

Things happen quickly at parties, so be prepared by getting ready ahead of time. Before the event, make sure the batteries for your camera and your accessory flash (if you have one) are fully charged. It is smart to carry extra batteries, especially if the party is indoors, since heavy flash shooting drains them quickly. And check to see that you've got plenty of room available on your memory card(s). It helps to have an extra in your camera bag.

If your camera suffers from shutter lag, the best technique is to anticipate the action. Press the shutter release

Using the camera's built-in flash at dusk brightened the subject and put catch-lights in her eyes. In Program mode, the camera found the correct exposure for the scene and then I used the flash compensation control to cut the flash's intensity, for a natural effect.

To convey a sense of party and fun, I shot this image using existing light and the flash at its lowest power to get the combination of blurred and sharp images in the same picture.

halfway so all of the camera's auto systems can start their job. Hold the shutter button in the halfway position and wait for that special moment before pressing the button all the way to capture it.

As a photographer, I think of myself as a director making a movie. I want a variety of shots at a party or special event that will tell the story from beginning to end. To do that, I try to take the following types of photographs:

Setting the Scene

These tell the viewer where things are happening. Get a few photos of the general area before the party really gets going.

Table Shots: Do the host or hostess a favor and, before the food is devoured, snap a few frames of the table settings and the food, and even people sitting and socializing at the tables.

Covering the Event

These photos show smaller areas, including shots like the following list.

Group Shots: Group shots make sure that everyone is included in the pictures. It's important for sports teams and wedding parties alike.

Close Ups: Don't forget a few detail shots of things like the wedding cake, a pile of birthday presents, or an arrangement of flowers.

Candid Shots: With those above images taken care of, shoot candid pictures of people.

Working with the Light

The key to great party pictures is capturing candids of people having a good time. And I don't mean people looking stupid, stuffing their faces with food, or exhibiting the effects of too much to drink. The next morning those pictures are just embarrassing.

At a party, try to fit in and not be conspicuous. Watch the little interactions that go on, of people chatting or dancing together. After all, you want to show people relaxed and enjoying themselves.

But sadly, lighting for indoor events like weddings, bar mitzvahs, birthdays, and other such events is most often awful. If your camera has a red eye-reduction preflash or strobe flashes, you can pretty much forget about candid photographs. A strobing flash hardly catches people relaxed and unawares.

So first try shooting without using a flash. Available light can sometimes produce lovely candid pictures indoors. You'll need to set the ISO to 400, sometimes higher if your camera can handle it, and see how it works using the available light. You might try waiting until people are near candle settings or overhead lights before taking the picture.

Flash is helpful at a party to reduce blur and digital noise, both of which can occurs when the shutter speed is relatively long. © Kevin Kopp

But most of the time the indoor lighting at these events is insufficient or unflattering (mixed fluorescent lighting produces ghoulish colors). Party pictures made using available light often end up being just too dark. Now it's time to work with your camera's built-in flash.

When using flash, take care to expose correctly. Often the flash isn't capable of covering the distance from the subject, resulting in underexposure. This can often be fixed by increasing the ISO setting to 400 or 800, which effectively increases the flash range.

Sometimes your subjects look great and correctly exposed, but the room or background behind them is black. This happens when the camera's default shutter speed setting is too fast to record detail in the background.

In this case, set a slower speed. The flashes on many cameras use a default shutter speed of 1/60 second in AUTO Exposure mode. Simply select Slow sync flash mode if your camera offers it, then switch to Program or Shutter Priority exposure mode and set the shutter speed to 1/30 or even 1/15 second. This longer exposure time will lighten the background without causing blur due to camera motion—unless you want to be creative and use the blur of lights for effect.

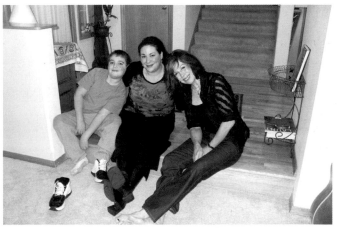

Red-eye is unattractive in portraits. One of the best ways to avoid it is to use a flash that you can position away from the camera's lens.

Red-Eye

One of the biggest problems with flash at parties is the red-eye effect. Red-eye is produced when the flash is too close to the lens, which catches the reflection of the flash off the blood vessels in the back of your subject's eyes.

You can reduce red-eye by not having your subjects look directly into the lens. Ask them to look off to a side, or even over your head. Or, try having people face each other, so they are not looking directly into the flash.

Another good red-eye solution is to use a remote flash on a cable so that you incease the angle of the reflections. The farther a flash unit is from the lens, the less the chance to get red-eye.

Also, there is the red-eye reduction option available in many cameras, which usually involves the firing of a flash (preflash) or a series of preflashes, causing the subject's pupils to contract. However, I try to avoid red-eye reduction systems because they are often annoying to my subjects. A final solution involves correcting the pictures in an image-processing program in the computer.

Weddings

Weddings are a lot of fun and offer a lot of opportunities for great pictures that will be treasured over the years. Shooting a wedding and all the activities that surround it is a great way to tell a story as well as record a good time. Of course this takes planning, so think about the story you want to tell before you start taking pictures. Make sure to take shots of the chapel and reception areas, or any festive outdoor spaces, before the wedding. Take photos that show the whole space, and detail shots that show just the altar, food tables, and floral settings. As people arrive, get shots of family groups, couples and, of course, casual portraits of as many participants as possible.

Indoor weddings are more challenging than outdoor ones because of lighting issues. Chapels and reception rooms are generally pretty dark or badly lit, so set a higher ISO and a slower shutter speed, just as you would for any indoor party where you need to use flash.

Using a zoom lens at its telephoto setting, I could stand about twenty feet from the minister and get this shot without disturbing the ceremony.

And since a wedding is basically a big party, many of the suggestions in the previous section about parties also apply. Most wedding photographers carry powerful off-camera electronic flashes that put out enough light to even override available outdoor light. They give the wedding photographer enormous flexibility. With your built-in flash or a small accessory flash, you won't have a professional's degree of control, but you can shoot good photos with your gear.

Tip: Bridal gowns are generally white and grooms are usually in a black tux. That means that you are facing a high contrast situation. Be more concerned about the bride's gown than the groom's tux. For example if you are photographing the couple and the bride is on your right, turn the camera so the flash is on the left, or hold your off-camera accessory flash to the left. Although the effect may be small, keeping the flash farther from the bride can reduce the chance of the gown becoming overexposed.

Weddings are romantic, and backlit pictures are a neat way to convey a sense of romance. Pose the bride and groom in front of something bright, like the stained glass

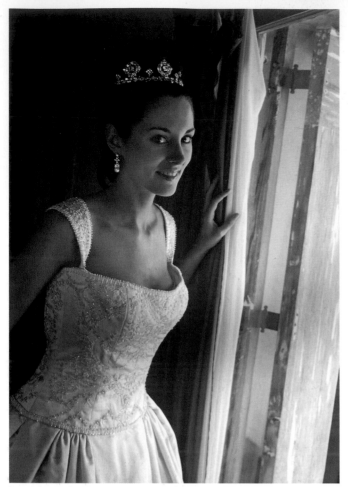

It pays to take a moment to consider the light in a scene. Here I decided to use the soft light coming through the lace-curtained window for this casual portrait of a bride.

A great time to get pictures is while the guests are arriving, before the wedding really gets going and it gets crowded. Remember to use common courtesy when photographing in a chapel during a ceremony, or even at outdoor events. Ask the family and the presiding cleric if they mind whether you shoot pictures. Turn off the sound in your camera if that is possible (usually in the set-up menu). Now your camera is silent and won't disturb the ceremony. Additionally, I think it is good manners when inside a chapel to turn the flash off and set the ISO to 400 (or higher with some cameras) to avoid disturbing the solemnity of the occasion.

Indoors with the flash off, you'll need to make sure that the image stabilization system in your camera or lens is activated (if you have one), then brace yourself against a wall or pew and get ready to shoot.

Candlelight: Sometimes at parties or weddings there is an opportunity to shoot distinctive pictures by candlelight. One way is to use only the flame from the candle (or candles) as the light source. To do this, turn off the camera's flash and set the ISO to 400 or higher. To create a very warm image, set the white balance to Daylight (sun icon); for an image that is just a little cooler, set the white balance to Tungsten (light bulb icon).

Your digital camera may have trouble taking pictures by candlelight because the light may be too low for proper operation of the camera's autofocus. It's often better to focus manually. Additionally, because candle flames are small points of light, exposure systems may not read them correctly and will try to compensate by overexposing the picture.

Many cameras have an autoexposure lock button. With this button you can meter the exposure for part of the scene (such as the subject's face) and then reframe the picture without the exposure changing. With candlelit photography, set the camera exposure system to its partial

windows in the church apse, or framed against the open door of the church. As with other backlit situations, you can use your flash to create various levels of detail in the couple. From flat silhouettes to fully detailed portraits, you can use your flash creatively for effect.

When photographing at any kind of event—a wedding, birthday party, anniversary, sporting event—you are going to take a lot of photographs. Remember the earlier advice to bring extra batteries, both for your camera and your flash unit (if you use an accessory flash). And also bring extra memory cards so you can record pictures at full resolution. People often ask for enlargements of these types of events, and you never know which shots are going to be the ones they will want.

Small details like this sign on the wedding limo can add a human touch to a wedding. Don't forget to look for them.

or spot meter setting. Move in closer and point the meter's target at something important in the shot; a face or a birthday cake. Press the shutter button halfway down and when the camera gets the exposure, press and hold the autoexposure lock button—usually marked AE-L, then move back and reframe the shot and press the shutter button down fully. Since candlelight exposures will be long, a tripod or some sort of support really helps to record sharp pictures.

In addition to using the light from the candle itself as your source, you can use the camera's flash to illuminate the picture while retaining the feeling or atmosphere of candlelight. Try to find a balance between the candle-light and the flash that makes the picture look like the candle is the only source of light in the picture. You'll need to experiment with the proper settings, but, if possible, use the flash minus exposure compensation. You want to prevent the flash from overwhelming, thus overexposing, the image.

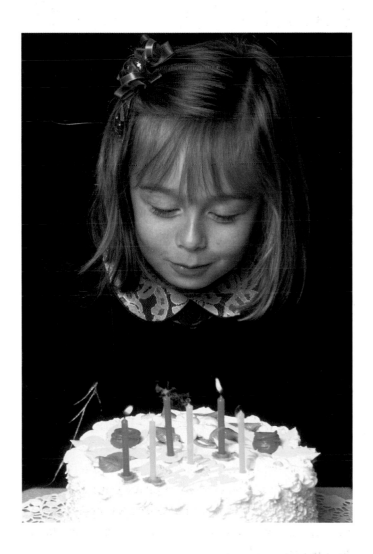

A Home Studio

Studio photographers are particularly good at using lighting to communicate subjective qualities. They make people and objects look good. But if you aren't a professional photographer, don't worry. Taking pictures in a small home studio need not be intimidating. Many really good photos are made with very simple lighting.

The Basics

A home studio allows you to control light and space, giving you a placc to take pictures of objects, such as collectibles, crafts, or art pieces, as well as a set-up in which to shoot portraits of friends and family. Creating a home studio is not nearly as difficult or expensive as you might think. The minimum pieces of gear include some sort of plain background and a good light source. It could be as simple as a large north-facing window and a reflector, or a pair of identical lights.

To begin with any home studio you need:

1. A digital camera with a short zoom lens, something in the range of approximately 35 to 105mm (in 35mm equivalent focal length).

2. A tripod. Very, very important!

3. A background. This can be a large piece of neutral colored paper, a long roll of photo background paper, or a large piece of tight weave fabric.

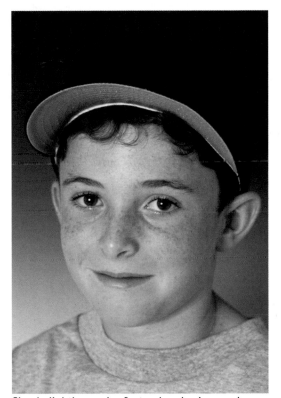

Simple lighting and a featureless background focus our attention on this boy's face.

4. Lighting. This usually consists of one or more lights (tungsten, halogcn, or electronic flash/monolight) with light stands.

5. Light modifiers, such as umbrellas, reflectors, light boxes, and softboxes.

Let's start with the small, simple tabletop studio.

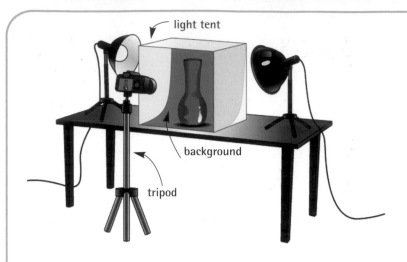

light tent

background

tripod

A Tabletop Studio

A tabletop studio is simply a miniature studio that sits on a table and is used to photograph objects that are relatively small. The illustration above shows the setup for a tabletop studio using two lights. In this case the object is in a light tent, a device that is helpful for photographing shiny objects. Otherwise, most objects can be photographed on the table without a light tent, in front of a blank background (any kind of smooth material).

A horizonless background is great for object photos and is simple to make. Just hang a large piece of white or colored paper from the wall onto the table. For example, hang a 20 x 30 inch (50 x 76 cm) piece of paper about 15 inches (38 cm) above the table, with the other 15 inches of the paper lying on the tabletop. Lay the paper with a gentle curve where table and wall meet, and you are all ready to shoot.

Lighting for a tabletop studio can be as fundamental as a single light with a white or silver reflector, or two matched lights as shown in the sketch above. The lights can be as simple as table lamps or commercially produced photo

lights. It is handy to have lights on stands, which are very useful with a tabletop studio. Having the lights a foot or two from the tabletop (30 to 60 cm) gives you more room to work with bigger objects than placing the lights on the table. When shooting objects on a tabletop, I like to shoot at the telephoto end of the camera's zoom.

Set the camera to AUTO or P and the white balance to match the lights you are using. Because the lights of a tabletop studio are close to the subject, even 100 or 200-watt lights are going to give good results with your camera set at its lowest (and best performing) ISO.

Note: Use the Daylight white balance setting for flashes and daylight fluorescents.

Next place the subject in the middle of the background paper or in the center of the light tent. I like to photograph objects with my camera set to a moderate telephoto focal length, for example 85mm using a D-SLR. Look at the subject on the LCD monitor or through the viewfinder and move the camera to a position until the subject is nicely framed.

Different subjects require different lighting, and this is where the real pleasure of a studio—the total control of the lighting—works its magic. In most photography, you have

Don't forget that you camera's close-up capability is useful for getting great shots of objects like coins, stamps, jewelry, or even crayons, in a tabletop studio.

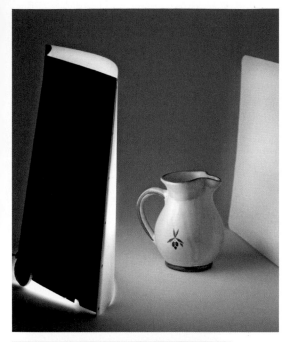

Using lights to create contrast helps reveal the textures in soft objects, such as this multimedia art quilt, entitled "Spring Forward, Fall Back" by artist Laurie Stone.

The Lowel Ego light (sold with the reflector card, above and opposite the light) creates a diffuse light that is great for recording professional-looking photographs, especially for online auction sales. The diffusion cover houses two coiled fluorescent bulbs that approximate Daylight color temperature.

To determine how much contrast you need, start with two lights, each placed on either side and equidistant from the subject, then take a photo. Look at the image and study the shadows. With two matched lights at the same distance from the subject, the shadows should be relatively faint.

If you need to darken shadows to sharpen shapes or to bring out textures in the subject, move one of the lights a bit farther away from the subject or replace it with a smaller wattage light. Take another picture and see if this creates more contrast.

Shiny objects such as ceramics or glass have the opposite problem. They are hard to photograph because their smooth surfaces reflect the lights. So these types of objects require soft lighting, like the diffuse light on an overcast day.

The easiest way to soften lights is to bounce them off of large white surfaces. To shoot a shiny subject, point the lights up so they bounce off a white ceiling. Or use a device like the Lowel Ego light, which works better than ordinary lights because the light shines through a plastic diffuser.

to cope with the available light and work around that. In the studio, you completely manage the light.

For example, soft subjects, things without shiny surfaces like a rag doll, a tee shirt, or a woven piece of art, need to be photographed with more contrast than a shiny subject like a glass vase. Contrast is used to emphasize form and texture.

The Portrait Studio

The earliest photo studios were home portrait studios. In the days before artificial (particularly electric) lighting, a glass atrium or room with large windows was the photo studio. Setting up a home studio, therefore, has a long and proud history.

In comparison to the tabletop studio, which is too small for taking pictures of people, a portrait studio requires a space the size of a small bedroom (perhaps 8 x 10 feet, 2.4 x 3 meters). The space has to be large enough for you, the camera, the lights, and the subject. If you have a room with large windows, you can sometimes use natural light for your studio work. But in order to be assured of controlling the light, you will need to invest in artificial lights.

Using plain backgrounds will remove distractions that can ruin a photograph and also serve to focus attention on your subject. Hang a large piece of plain paper or well-ironed fabric on the wall. It should be at least four to five feet wide (1.2 to 1.5 meters) for headshots, and eight to ten feet wide (2.4 to 3 meters) for full bodywork. When you shoot, place your subject three to four feet (.9 to 1.2 meters) in front of this background. The background should hide the wall and fill the picture frame.

Backgrounds can be any color, but need to complement your subject. For example, fluorescent colors may be fun, but they don't work for formal shots. On the other hand, you wouldn't want to photograph kids in front of a boring black background. Choose a background that fits your subject.

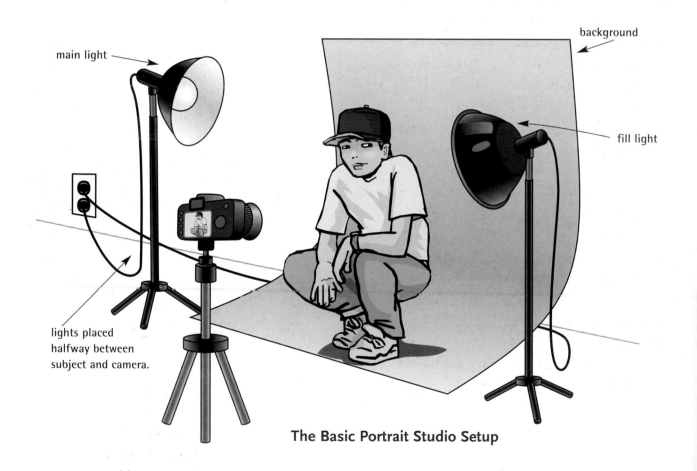

The Basic Portrait Studio Setup

Your built-in camera flash will work for some subjects, but as with a tabletop setup, a set of two matched lights is a better way to control the look of your image. Minimally, head portraits require two 150-watt lights, but bulbs of 250-watt or equivalent power are best for most other studio work. A fluorescent device like the Lowel Ego light for tabletops stands on its own, but light stands are necessary for portraiture and model work.

The best solution for establishing a home studio is to look for lighting kits. These packages usually contain two matched lights, two reflector light housings, two light stands, a pair of photo umbrellas, and a carrying case. Available kits range from ones that use simple household lamps to ones that offer electronic flash units. While these flash units are the lights of choice for many professionals, you must have a PC Sync plug or a hot shoe on your camera to use them. Most D-SLRs have hot shoes atop their viewfinders. If your camera doesn't have a PC plug, you can use a hot shoe to PC adapter that slides into the hot shoe. You plug your flash cable into the adapter so the flash will fire when the shutter release is depressed. However, most point-and-shoot cameras do not have hot shoes, so you must use tungsten or fluorescent lamps with them.

Tip: While there are a few studio flash systems that link to a camera's D-TTL system, determining the correct exposure usually requires either a special handheld flash exposure meter or experimentation. A simple method is to set up the lights and then take a photo with the camera aperture set to f/22. If the image is too dark, open the aperture one stop (to f/16) and try again. Continue the process until you get the correct exposure. If the first photo is too bright, either reduce the power output of the flash or move the lights farther from the subject.

Courtesy Opus Photo
Lighting Equipment

A Bare Bones Studio

Sometimes it is difficult to find photographic lighting equipment in your local area. An alternative are Halogen work lights, which are often available at a nearby big box hardware store.

These work lights put out a lot of light and heat. They are rugged, inexpensive, and use 2950K tungsten halogen lamps. That is a little warmer than 3200K tungsten studio lights, but close enough to provide accurate colors with your camera's white balance set to Tungsten.

These 500-watt work lights cost between $10 and $20, so two matched lights for a studio cost $40 or less. For use as studio lights, these lights have to be suspended at various heights, which means you will have to buy a couple of light stands. Alternatively you can attach the work lights to a wall or a couple of ladders.

Caution: These are very hot lights that consume a good deal of power. Always be careful to use the built-on handles to move or adjust the lights. Two work lights will draw 1000 watts of electricity, which can trip household circuits.

Their light can be harsh, so the simplest way to soften it is to bounce it off a white ceiling. In addition, most hardware stores carry white translucent replacement panels made of plastic for use with standard fluorescent fixtures, which cost under $10 apiece. These are approximately 2 x 4 feet, (.6 x 1.2 meters). The panels come in several surface types, and I think the frosted white are the ones to get. They should be placed about 24 inches (60 cm) in front of the work light for proper diffusion. The trick here is supporting the panel in front of the light, so you may need to build some sort of support structure.

Notice in the drawing on page 78 that the camera is on a tripod. In the studio, a tripod serves several important functions. The first is to provide a stable shooting platform. A tripod is advantageous even for cameras or lenses that have an image stabilization system.

But perhaps more importantly, a tripod allows repeatability, permitting you to frame a face or an object and take several shots from the same position. This is particularly important in portraiture, where you'll want to take a number of pictures of your subject to make sure that you end up with a really good one. It also allows you to get out from behind the camera and engage more with your subjects.

The two-light setup is very flexible and, over time as your skills improve, you can add other accessories like photo umbrellas and light diffusers to provide finer control of the light. Don't be afraid to experiment in the studio. Move the lights around and learn how different placements change your pictures. Try different focal lengths and see how you like the results. Take a number of shots so you have choices when reviewing the portraits. Remember, all mistakes are "delete-able."

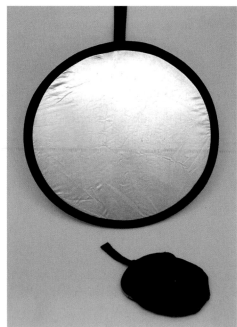

This circular reflector is white on the other side, providing a choice for altering the quality of light on a studio subject.

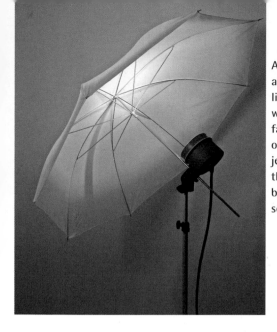

An umbrella attaches to your light source with the inside facing the object or subject. It modifies the light by bouncing and softening it.

Light Modifiers

A light modifier is anything that changes or alters the light source. It can be as simple as a white piece of poster board held near a face to bounce light into a shadow, or as sophisticated as a soft-box device that fits over a flash to soften its light. Softer light has lower contrast, which is almost always more pleasing for people photos.

A reflector is the most basic light modifier. It can be made from a number of different things: a white sheet of paper, a large piece of white foam board, or a commercial product constructed especially for this purpose. Using a reflector is simplicity itself. Taking a picture by window light, seat your subject by the window and use a big white poster board (or a friend holding up a white sheet) to bounce some of the window light into the shadow side of the subject's face. Move the reflector around to determine at what position the shadows are lightest, and then take your photo. And always remember to keep the reflector and friend out of the frame.

Commercially made reflectors are more efficient than pieces of white board and are fairly inexpensive. They are an easy way to improve pictures. I carry a wonderful circular reflector in my camera bag. It works for portraits or any other time I need a little extra light, for example when shooting flowers. When open, the reflector is 24 inches in diameter (60 cm), but with a twist of its supporting metal hoop, it folds down into an 8 inch (20 cm) wide carrying case. The reflector has a white side and a silver one.

Photo umbrellas, another type of light modifier, are also useful for portraiture. They look like ordinary umbrellas except they are made of special silver, gold, or white material. Umbrellas soften and spread the light to cover a larger area of a scene. They are often sold individually or with photo lights as part of a kit that includes the umbrella and light stand.

Once you've set up a home studio here's how to use it.

Basic Lighting for Portraits

The idea behind good lighting technique is to make people look good. You can use the light to make a chubby face thinner or a thin face fuller. You can eliminate harsh shadows while softening blemishes, lines, and wrinkles, thus wiping several years off your subject's face.

To take portraits that go beyond simple snap shots, it helps to set-up a home studio and to use two lights to control both highlights and shadows. The pictures in this section were taken with two lights of equal intensity mounted on light stands. I mounted a photo umbrella on each light. Studio lights usually have a place for you to attach an umbrella. If needed, there are also simple clamp devices that you can get to hold an umbrella.

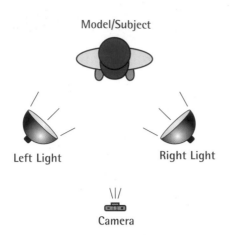

Model/Subject

Left Light Right Light

Camera

Balanced Lights

Let's start with both lights equally distant from the subject. For a typical portrait shoot, place the two lights about six (1.8 meters) feet from the model and about half the distance between the model and the camera.

Notice how the shadows outline the model's cheek bones and frame her face below her chin. The nose is flattened and almost disappears into the face. This is a friendly open look.

Broad Light

Full frontal (broad) lighting is the most commonly used type of lighting. The main light shines on the subject's face and produces slight shadows that give the face some shape and texture. The light fills the face and makes it seem broader in the pictures, hence the name. (You are using broad lighting when your subjects face the camera as you shoot with the sun behind your shoulder or with the flash on your camera.) It works best with thin or long oval faces. Unfortunately, it tends to bring out blemishes and wrinkles.

Moving the light on the photographer's right about three feet farther away deepens the shadows on that side of the model's face, creating a stronger image. The model's nose and cheeks are strongly defined.

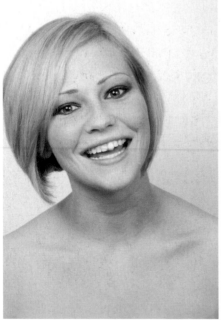

With the two lights at equal distance from the model, the lighting emphasizes the woman's cheeks

By moving the light on the photographer's right farther away, the shadows get darker producing a totally different look. Now the shape of the model's profile dominates the picture.

Narrow Light

Narrow lighting is the opposite of broad lighting. Now the light source comes from slightly behind the subject. The side of the face away from the light is darker and it has the effect of thinning fuller, rounder faces.

With the model looking into the light on the left, the details of her face are softened and her skin glows. When using glamour lighting, compared to standard broad lighting, the nose and cheekbones are not as prominent.

Moving the left light away from the model darkened her face creating narrow lighting

Hair or Rim Light

Back lighting that comes from above a subject's head is called a hair light (also sometimes referred to as a rim light or shoulder light). It lights up a subject's hair and shoulders, separating them from the background. It is commonly used in conjunction with the other types of light. Produce this type of lighting by posing subjects with a strong light behind them, and then use your camera's flash to light up their faces.

Glamour Light

Glamour lighting is similar to broad lighting, although the light is usually a little farther from the camera. The subject looks up into the light. This makes the face shine very brightly compared to everything else. It wipes out skin blemishes and wrinkles and makes the face glow, like the old publicity shots of Marlene Dietrich or Marilyn Monroe.

Tip: A photographer's trick from the Hollywood studios to soften portraits is to cut a piece of sheer women's hose (6 x 6 inches, 15 x 15 cm) and hold it taut over the lens. The fine, crosshatched fibers diffuse the light that reaches the lens, softening wrinkles and facial lines.

Special Situations

There are a number of situations where the lighting may be out of your control, and often poor, leaving you to work at the edge of your camera's capabilities. Actually this chapter should be called "Really Challenging Photography!"

You have to think on your feet because every special situation is different. Shooting a rock concert indoors is different than shooting one outdoors, and different than shooting an outdoor concert at night. This means it is difficult to present techniques that will work all the time. To get good photographs, start with these ideas, but always improvise according to what is happening around you.

Digital photography has made shooting tricky situations a lot easier than with film. You can follow my suggestions and take some pictures, then review them on your camera monitor and make adjustments accordingly, seeing whether you need to change the ISO, the white balance or the exposure settings. Immediate feedback wasn't possible with film because it took hours to be processed.

Interior Light

There are numerous lighting challenges when photographing indoors. From the low light levels found in restaurants, businesses, and homes, to the mixed fluorescents in offices and factories, indoor photography is challenging.

You will often find a mixture of tungsten, fluorescent, and natural light in restaurants, museums, or offices. It is helpful to use the Custom/Manual white balance setting if your camera has one.

The trick to photographing offices, rooms, and other interiors is to get the indoor light to look natural and to avoid overexposure due to existing light entering from windows. You can sometimes use the camera's built-in flash successfully, but it is better to use a powerful accessory flash or additional lighting.

In general when shooting indoors, set your camera to ISO 200 or 400 and the white balance control to match the lighting. For instance, if the space you are photographing is lit with only tungsten lights, or only fluorescents, you'll get the best results setting the white balance to that type of light. If the lighting is a mixture, you can use the Auto white balance (AWB), or, if your camera has a Custom/Manual white balance setting, learn how to use it.

When using a flash, set the camera's white balance to AWB, Daylight, or the Flash setting if your camera has one. Also, turn on the camera's image stabilization or use a tripod.

Tip: Add light to the scene by turning on as many lights as you can in the room.

Zoom to the camera's widest angle and carefully frame the picture. Set the camera to the P exposure mode and take a picture with the flash. Then review the image in the camera's LCD. If the walls are dark, set the exposure compensation control to +1 or +2 to get better results. If windows in the room are overexposed and washed out, try increasing the shutter speed a stop or two.

Light colored walls will bounce the light, lightening dark areas. But rooms with dark walls suck up the light and are very difficult to shoot without a great deal of lighting.

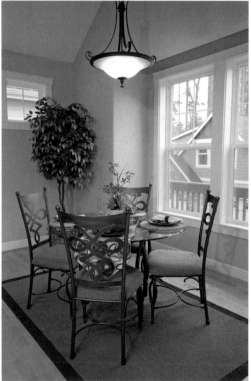

Without flash, the camera in Program exposure mode set the shutter speed to 1/3 second and used the widest aperture on the lens, resulting in the window area becoming overexposed. To correct this in P mode, I raised the built-in flash and the shutter speed preset to 1/60 second. This still wasn't fast enough to get what I wanted, so I shifted the shutter speed to 1/125th second, capturing more detail through the windows as seen in the bottom photo.

The only light for this image is the bright flame of the blowtorch. In order to expose the flame correctly, the unlit background is underexposed and detail is lost.

The camera's flash was used to reveal the details of the workbench.

Stained Glass Windows

Light streaming through a huge stained glass window is as impressive and meaningful to people in this day and age as it was to medieval folk. Photographing a stained glass window is relatively simple. First, don't shoot when the sun is pouring through it unless the light rays themselves are the subjects of the photo. Bright sunlight will overexpose and burn out the lighter colored areas. Shoot when the windows are illuminated by blue sky or, even better, by an overcast one.

Setting ISO 100 or 200 should generally be sufficient. Turn off the flash—many churches don't allow flash pictures anyway and you want to get the full effect of the light coming through the colored glass. Now zoom in on the window until it fills the frame. If you can't get the window to fill the frame, the camera's metering system may overexpose the picture, so and you'll have to use a -1 or -2 exposure compensation to correct.

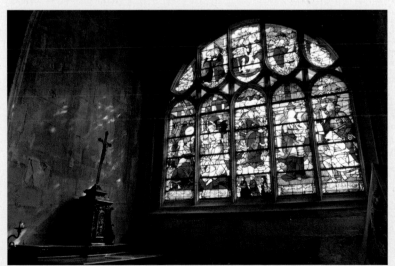

Diffused light on an overcast day helped keep the highlights in this window from washing out.

Remember to look carefully at the highlights. Washed out highlights are problematic and with stained glass, the photo is often more dramatic if the surroundings are dark.

Concerts, Symphonies and Stage Shows

Lighting at live performances can be all over the map. Sometimes a stage will be fully lit, sometimes there will be a single spot light, sometimes it's a mix of the two, and sometimes all the lights will be different colors. Photography at these events means dealing with a variety of changing lighting situations. To get the best pictures you need to watch the lights and adjust for them.

But let's begin at the beginning. Stage lighting is based on the use of very large, powerful tungsten floodlights. Although a camera set to Auto white balance will generally produce good photographs, I prefer to use Tungsten white balance. This usually helps to assure that the colors you see are the colors you get.

The exposure difference between the stage and the house is huge. This shoot of a symphony hall was a one second exposure at f/4, while the stage was f/4 at 1/60th of second.

The light on a stage seems bright, probably because you are sitting in a dark theater. But relative to daylight, it's actually pretty dim. So increase your ISO to at least 400 or 800 when shooting a concert.

Remember that digital photography lets you review images on the spot. Don't be afraid to take a test shot and change your settings until you get the desired result, especially in tricky lighting situations.

Unless you are seated or standing at the edge of the stage, turn off your flash. Most flashes are simply too weak to reach performers on stage. Firing your flash may make you feel part of the concert, but all it will do is burn out your camera battery quickly.

You'll also find it easier to get accurate exposure readings by switching the camera to the spot metering setting. The usual matrix or patterned metering (sometimes called evaluative) will work if you are close enough for the stage to fill the camera frame, but I'd go with spot metering.

When the entire stage is lit, it's easiest to simply let the camera meter find the exposure and set the camera controls. The problems occur when there are spot-lit areas on stage, or if a performer is framed in a spot light.

Spotlights are much brighter than other lighting on the stage. It's one of the reasons I recommend using spot or partial metering if your camera offers them. Average, or evaluative, metering will tend to choose exposure settings for the whole stage that will result in the spot-lit performer becoming washed out. Whenever you see a spotlight in use, make sure you get your exposure reading from the area it is lighting. With spot or partial metering, place the center spot of the viewfinder over the spot-lit area to get a reading, locking it, and then reframe the image.

Tip: A theater audience hangs on every word and every note at an opera performance, symphony concert, stage show, or recital. Be a courteous photographer. If you have a P&S camera, go into the camera's menu to the setup page and find the menu line for "Sound," "Beep," or "Shutter" and turn off the camera sounds.

It's harder to silence a D-SLR. Its noise is due to the mirror slapping up when you take a picture, and it can be loud enough to disturb people. In symphony, stage show, or ballet situations, I try to muffle the camera by wrapping a jacket around it. Of course at a rock concert, where the noise level is over the top, camera noise is hardly a problem.

Rock Concerts

Photography at rock concerts is similar to the general stage photography just described, with one major exception. At most stage shows, symphony concerts, and ballet performances, the lighting changes rather slowly and it's manageable to photograph.

But rock shows make a point of using varied extravagant lighting effects that range from flashing strobe lights to pyrotechnic displays, and they are not easy to photograph. The effects are so much brighter then the existing stage lighting that if your camera used their bright light for it's exposure readings, the performers would end up way too underexposed.

There is a simple way to get photos that capture these effects. Switch the camera to the Manual exposure mode. Before the bursts of lights occur, find the correct exposure for the stage using the camera's spot metering system. Now when the effects light the stage, the exposure system won't try to cope with the bright flashes by changing the settings.

The pyrotechnics or strobes will appear in the photographs as blasts of largely washed out bright spots. But while you generally don't want washed out areas in a picture, I think it works to convey exactly what you're seeing in this situation.

Since the lighting at rock concerts constantly changes, it may be helpful to keep the white balance set to Daylight and let the camera record the colors as you see them on stage.

© Jeff Wignall

One goal of sports photography is to use shutter speed to control motion and freeze the action. Sometimes, however, it is fun to use a shutter speed just slow enough to create a small amount of blur, giving a sense of motion, as in the arm and feet here.

Sports and Action

Like being at a concert, you may be far from the action when taking sports photos. Watching tiny figures from a distance run around like crazy, whether outside on a field or inside on a court, presents certain photographic challenges

With sports photography, the D-SLR is the type of camera that truly shines. D-SLRs focus quickly, and most offer focus tracking, making it easy to follow the action. They can take bursts of several frames per second to make sure you can get the peak-moment shot, and you can use very long lenses on the camera. If you are serious about sports photography, you'll want to consider buying a D-SLR if you don't already have one, along with a long lens. But

don't rule out newer EVF models with 18x zoom lenses. By pre-focusing these cameras, you can also get excellent sports action shots.

And remember to forget the flash. You'll have to pay particular attention to the available light, because the light from a built-in flash, or even an accessory flash, will rarely reach far enough to have a positive impact on your photo.

Outdoor Sports

Whether it's a Little League game or a pro championship playoff, sports are about action, and sports photography is about capturing action at its peak. This requires you to pay attention to every moment and to anticipate what will happen in any play. Your mind has to focus on the action, not on how to select the settings for your next shot—your camera needs to be set and ready.

Shutter speed plays an essential role in sports photography, whether you want a fast speed to freeze the action or a slow one to blur it. There are two ways to set high shutter speeds to stop action. Perhaps the best way is to select Aperture Priority mode and use the widest aperture you have—for example f/2.8. Now the camera's exposure system will use the fastest shutter speed for the correct exposure at this aperture. Since you are probably shooting players at a distance, it's less important to have the large depth of field you get at smaller apertures.

A second way to stop action when you shoot outdoors is to select a relatively fast shutter speed, such as 1/250 second or shorter, using Shutter Priority mode. Then let the camera select the correct aperture.

Outdoor sports photography requires a little planning to make the most of available light. It starts with where you sit in the stands. I try to get seats so that the sun is shin-

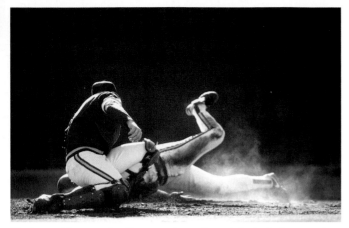

Photographing sports often requires a long telephoto lens, probably with a minimum focal length of 400–500 mm. In fact, this shot was done with a 600mm focal length.

ing on the field and not in my face (or into the camera lens.) Find seats on the west side of the stadium for afternoon games, or the east side for morning games.

You'll most likely use your digital camera with its zoom lens at the longest focal length, and the longer that lens, the better. Depending on how far away you are, the telephoto setting of a compact P&S with a 3x or 4x optical zoom is probably not powerful enough to really be of use.

At full extension, a variable aperture zoom lens is slower than at wide-angle settings, meaning the aperture can't be opened as wide. This means that less light gets to the sensor, and that means longer exposure times. With these lenses, you'll find the best success with higher ISO settings and with image stabilization turned on (if your camera or lens has an IS system). But remember that IS only reduces blur from camera shake. It doesn't freeze the action on the field.

If you see photographers covering the game for the local papers or one of the wire services, you will probably notice the huge size of their lenses, a trademark of professional sports photographers. These lenses are large and costly because they offer maximum lens apertures often

as wide as f/2.8, compared to the f/5.6 maximum aperture of many consumer zoom lenses.

These fast telephoto lenses are designed to be superbly sharp, even at wider apertures, so the photographer can get the proper exposure at the fastest speed possible. Yet even with these fast long lenses, many photographers will have their camera on a monopod or tripod. This helps reduce camera shake and fatigue. These big lenses are heavy, and it is no fun handholding them up to your eye for hours.

Panning

One way to get better peak-of-action shots is by following the play in your viewfinder while moving the camera (panning) to keep players centered in the frame. With your eye to the viewfinder, it's easier to anticipate what's going to happen and be ready to press the shutter at the right moment.

Instead of using a fast shutter speed to freeze this biker's motion, a sharp subject against a blurred background was created by panning the camera.

The trick to panning is to keep the camera motion smooth and to press the shutter release while the camera is moving. A simple way to pan a subject is to point the camera at a group of players and place the viewfinder's central markings over one of them. Then move the camera to follow the motion, keeping the player—or sports car or horse, or whatever—in the same place in the frame. Keep your motion smooth and don't stop the camera to press the shutter release. Learn to snap the photo while keeping the camera panning.

Indoor Sports and Night Games

Photographing sports indoors or at night games is, of course, more difficult than shooting outdoors in the bright sunshine. While the lighting in indoor stadiums may seem bright, it doesn't come close to daylight. Even at ISO settings of 400, exposures will require fairly long shutter speeds.

At night games and indoor venues, some sort of camera support always helps. Even bracing the camera on the seat in front of you or a nearby railing can improve sharpness. If you're really into sports photography, a lightweight monopod or a tripod is a good investment.

Increasing your camera's ISO setting beyond 400—to 800 or even 1600—will allow you to shoot at faster shutter speeds. Experiment and evaluate how much noise you really get at higher ISO settings. Shoot at a variety of ISO values. Then compare test prints from each setting if you plan to make prints of your photo files.

Generally the AWB setting will correct for the colors in stadium lighting. But some locations, especially school fields, may be a mix of lighting, like tungsten-halogen and halcyon lamps. This mix can mislead a camera when set to AWB. Experiment with the available white balance presets and, if you are still unhappy with the results, use the Custom (Manual) white balance technique that is found on many digital cameras to determine the actual color temperature of the existing light.

The ISO was set to 400 and the camera was braced on an empty seat in front of the photographer to get this shot at a night baseball game. © Kevin Kopp

Index